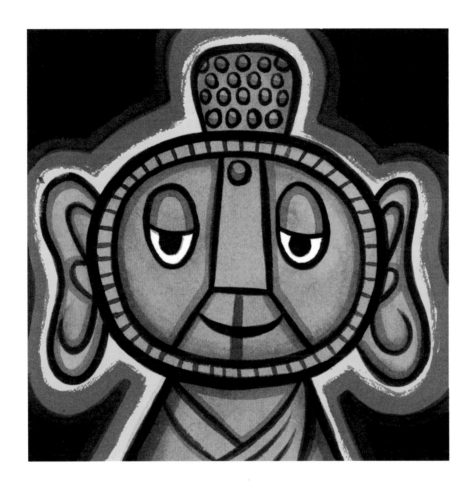

Dharma Delight

by Musho Rodney Alan Greenblat

Preface by
Roshi Enkyo O'Hara

Foreword by
Richard Thomas

TUTTLE Publishing
Tokyo, Rutland Vermont, Singapore

Acknowledgements

Thanks to Josephine my mother for getting me started.
Thanks to my father who let me turn the attic, garage and porch into art studios.
Thanks to Deena Lebow my wife for talking it all over with me and laughing about it.
Thanks to Cleo and Kimberly my daughters who helped me to grow up (almost).
Thanks to Gloria Lebow my mother-in-law who I should have listened to more.
Thanks to Roshi Enkyo O'Hara for creating the Zen circle that I now sit in.
Thanks to Sensei Joshin O'Hara for looking at the world in a totally different way.

Dedication

Dedicated to my dog Loki 1998 - 2013. Goodbye little white shadow.

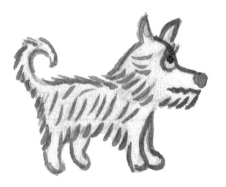

Copyright

Contents

Preface
6

Foreword
8

Introduction
10

Buddhas
16

Bodhisattvas
46

Gate Guardians
62

Jataka Tales
74

Koans
90

Zen Training
112

Notes
120

Preface

As Buddhism has come to the west, it has brought many and varied teachings, some of which are difficult to comprehend and, most of all, to put into practice in our everyday lives. In this amazing book, author Musho Rodney Greenblat has accomplished an extraordinary feat: he has delivered the essence of the Dharma in a witty, delightful and also very accurate way, making it possible for readers to realize how the teachings function in our lives.

The "Dharma" is a word describing the many teachings of Buddhism. The author, beginning with his own experience, offers us a creative and marvelous window into the central teachings of Buddhism: the Four Noble Truths, the Sutras, the Bodhisattvas, and most of all, the profound teaching of Buddhanature and one's own role in the world.

Musho – that's his Buddhist name – has practiced with me at the Village Zendo in Manhattan for many years. He serves as a Senior Student of Zen, giving talks and instruction. Through this experience, he has found a way to communicate many of the hard-to-understand mysteries of the Dharma. Using story, wit, and hilarious images, he gives us ancient Jataka tales, traditional teachings, koans, and 21st century experiences.

Buddhists often say that the Dharma comes in many flavors, but has a single taste: the taste of liberation. So, too, this extraordinary book offers the joys and delights of the many ways of appreciating the teachings, and still also directly renders the teaching itself: how to be free.

Uniquely, the book is full of lively illustrations of serious matter – just like life! Be warned! There are profound teachings here. And just like the title, this one is truly a delight.

Roshi Enkyo O'Hara

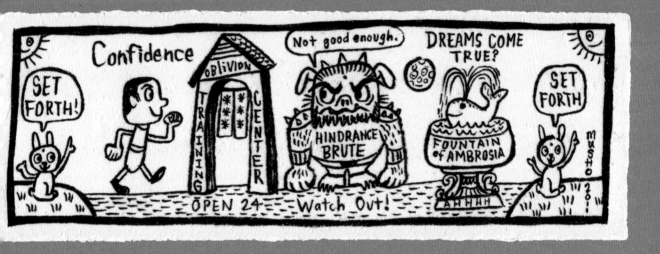

Foreword

"LIFE AND DEATH ARE OF SUPREME IMPORTANCE......TIME SWIFTLY PASSES BY AND OPPORTUNITY IS LOST.....DO NOT SQUANDER YOUR LIFE." - from the traditional *Evening Gata*.

Wow. Serious stuff.

Indeed, the whole project of Buddhism can seem like heavy furniture in a room suffused with high seriousness of intent. And coupled with our American Puritanism and penchant for self-improvement, the prospect of alleviating our suffering and the suffering of others--a joyful aspiration indeed--can come to seem unnecessarily grim.

Enter Musho Rodney Alan Greenblat, bearing in hand *Dharma Delight*. If meditation is indeed the seat of ease and joy, Musho is a wonderful companion and guide. His book-- a kaleidoscopic cornucopia of Buddhist history, teaching and symbol-- populated with a cast of characters both traditional and original, is a Dharma delivery system powered by pleasure as well as wisdom. Tortoises, pandas and sentient beans join hands with Bodhidharma, Avalokiteshvara and Buddha (in a spaceship, of course) to take us on a journey of liberation. And liberated is how I felt as I wound my way through its colorful and heartfelt pages.

And even though the images in the book are in many ways classical in their depictions of Buddhist iconography and Dharmic code, they are also a reminder of both the great Comedy of life and the hearty laughter of Zen itself --one of the funniest paths to freedom ever invented. As a Zen student I may not yet have realized the sound of one hand, but as an actor, I know very well the sound of two and I send thunderclaps of applause and nine bows in Musho's general direction. Open his book and become intimate with joy!

Richard Thomas

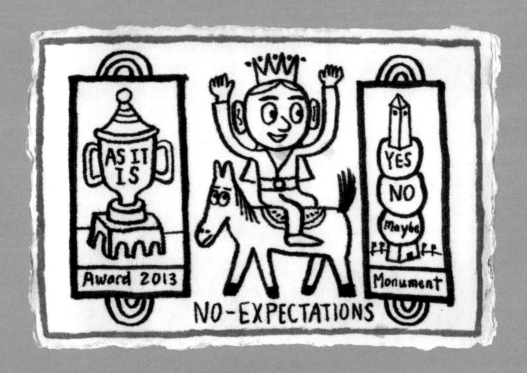

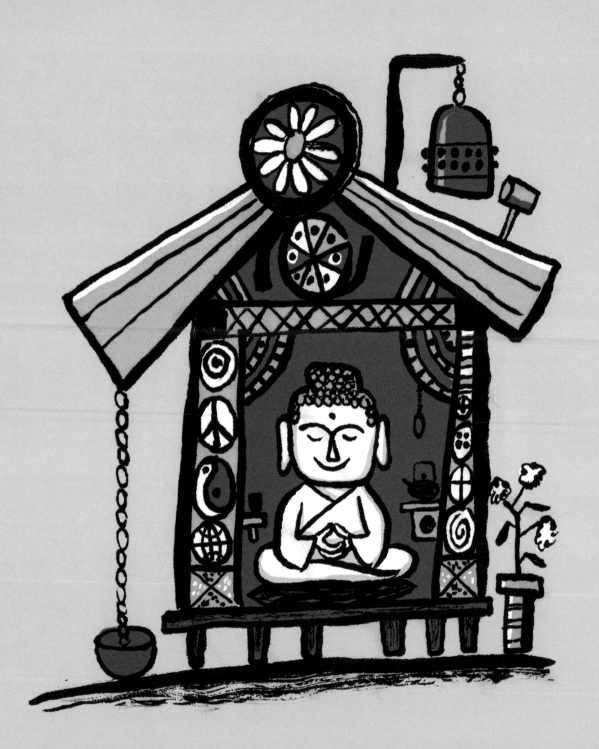

INTRODUCTION

When visiting the old temples of Japan as a tourist, I had many questions.

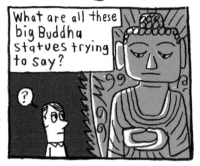

What are all these big Buddha statues trying to say?

?

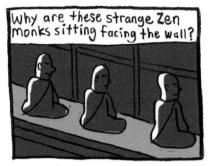

Why are these strange Zen monks sitting facing the wall?

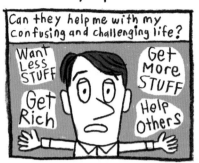

Can they help me with my confusing and challenging life?

Want Less STUFF

Get Rich

Get More STUFF

Help Others

My friends in Japan could not answer. Returning to New York City, where I live, I decided to find a Zen temple, do meditation and find out for myself.

I discovered a nearby Zen group and started learning to meditate. I attended lectures and then a week long retreat. Gradually the big Buddha statues started to speak. The Zen monks sitting facing the wall did not seem so strange.

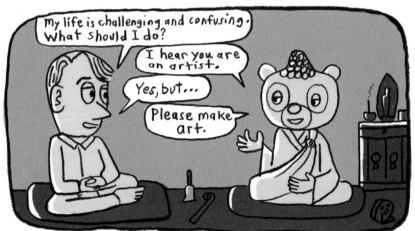

My life is challenging and confusing. What should I do?

I hear you are an artist.

Yes, but...

Please make art.

Then I began to experiment making artwork based on what I was learning and discovering. This book is the result. I'll start with a little introduction to the Dharma as I understand it:

REVERENCE

SINCERITY

The Buddha Dharma

"The Dharma" often refers to the teachings of the great Shakyamuni, the historical Buddha of India who lived more than 2500 years ago. His teachings range from simple poems and stories to epic philosophical dialogues that challenge all assumptions about the nature of time and space. Cool! Very basically he taught:

Shakyamuni
Siddhartha
Gautama
Buddha

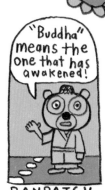

"Buddha" means the one that has awakened!

PANDATSU
(zen Panda)

The Four Noble Truths

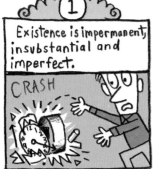

① Existence is impermanent, insubstantial and imperfect.

CRASH

② Our suffering is caused by clinging to Permanence, substance and perfection.

LASTS FOREVER

34.95

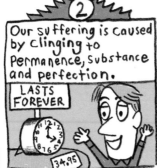

③ There is a way to end suffering and live in freedom.

The middle way...

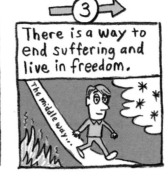

④ The Way is called the eight fold Path.

1. Right View
2. Right Thoughts
3. Right Speech
4. Right Action
5. Right Livelihood
6. Right Effort
7. Right Mindfulness
8. Right Concentrati.

Shakyamuni taught this path in amazing ways for forty years. His teachings were memorized and written by his followers, and then collected into big and small books called sutras. The sutras are still being studied and translated, and the wondrous Buddha Dharma keeps spreading and clearing a way to end suffering.

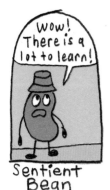

Wow! There is a lot to learn!

Sentient Bean

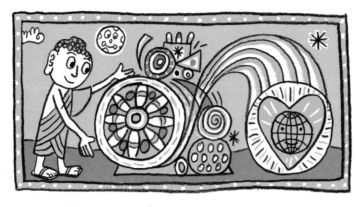

So the Dharma starts with shakyamuni Buddha?

MUSHO

The Buddha turns the Dharma Wheel, and reality is shown in all its many forms!

 WISDOM

The 24/7 Dharma

 COMPASSION

Shakyamuni started the Buddha Dharma — but there are many more Dharmas than that. Dharmas were happening before him and after him too, including NOW! There are billions and billions of Dharmas happening all the time, and every one of them can give us the opportunity to look, listen and reflect. For example:

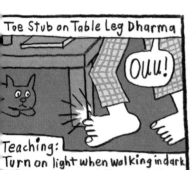

Toe Stub on Table Leg Dharma
OUU!
Teaching: Turn on light when walking in dark

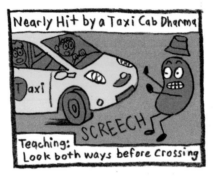

Nearly Hit by a Taxi Cab Dharma
Taxi
SCREECH
Teaching: Look both ways before crossing

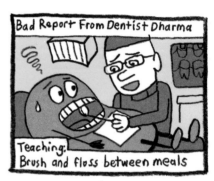

Bad Report From Dentist Dharma
Teaching: Brush and floss between meals

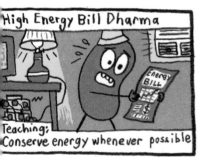

High Energy Bill Dharma
Energy BILL
Teaching: Conserve energy whenever possible

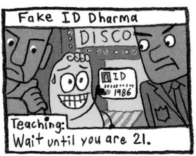

Fake ID Dharma
DISCO
ID 1986
Teaching: Wait until you are 21.

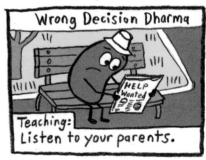

Wrong Decision Dharma
HELP Wanted
Teaching: Listen to your parents.

...but I didn't like what my parents were telling me.

So the Dharmas appear everywhere if we are awake to them. Some Dharmas are very difficult and require hardship and long hours of practice. Often the most challenging teachings are the ones that offer the most insight and unexpected gateways to FREEDOM.

So what IS Dharma Delight?

The Dharmas are BOUNDLESS, I vow to master them.

Dharma Delight

We all experience delight now and then.
Sometimes there are great delights:

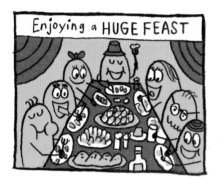

Enjoying a HUGE FEAST

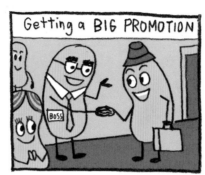

Getting a BIG PROMOTION

Winning the GOLD MEDAL

Sometimes there are small delights:

Drinking tea from a FAVORITE CUP

Feeling the warm SPRING SUN

Hearing a BABY LAUGH

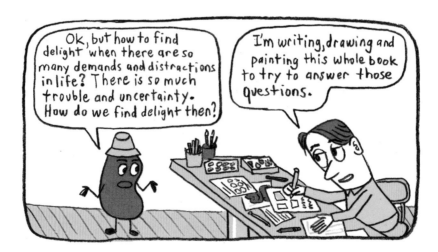

Ok, but how to find delight when there are so many demands and distractions in life? There is so much trouble and uncertainty. How do we find delight then?

I'm writing, drawing and painting this whole book to try to answer those questions.

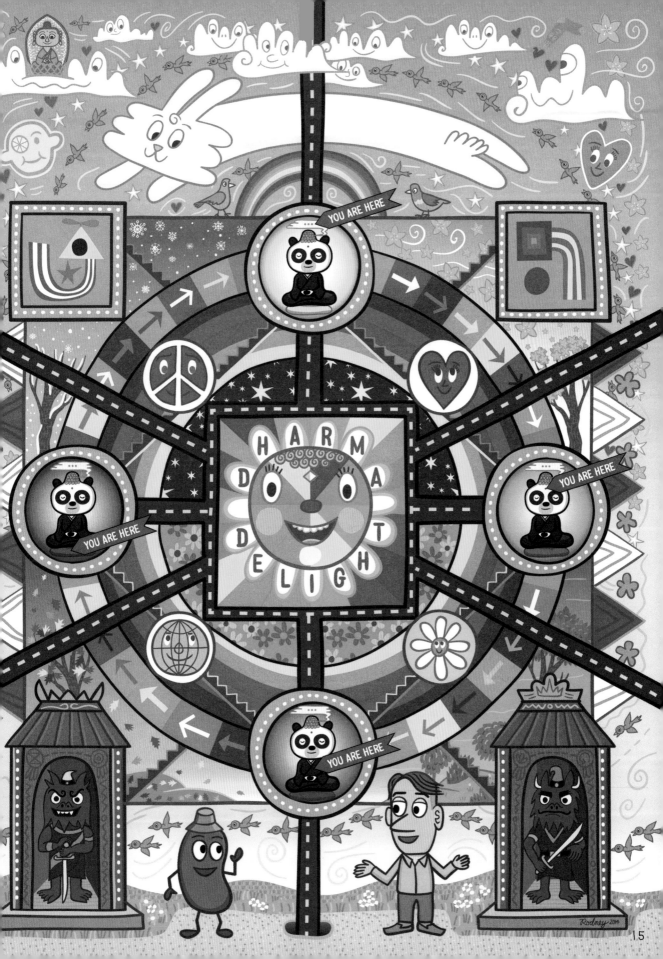

15

The GOLDEN MOMENT (ordinary.)
Happening over and over again.

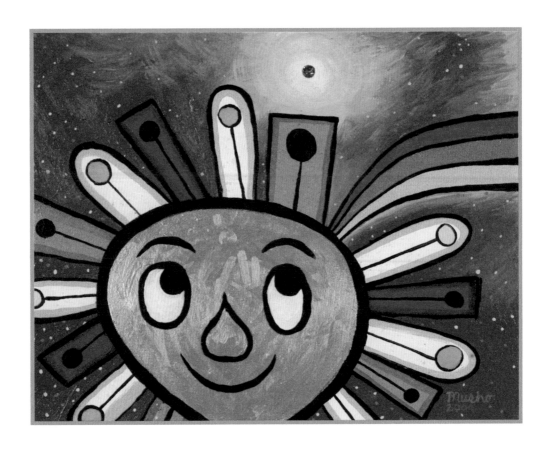

A Buddha for everyone,
awake to the world,
as it is wonderful.

ENLIGHTENMENT EVE

Finally Shakyamuni sat on a little hill under a tree and vowed not to get up until clairity came.

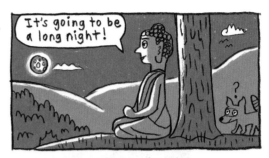

Soon his thoughts were filled with doubt as demons of desire and delusion taunted him.

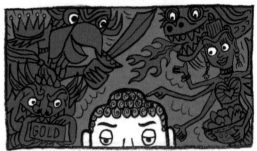

He forged on through the night, resisting the demons, who eventually left in disgust. He then became calm and alright with himself.

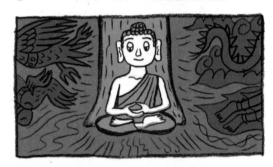

Looking up in the dawn sky he saw the morning star shining and, suddenly, the clarity that had eluded him naturally appeared. He touched the ground in gratitude.

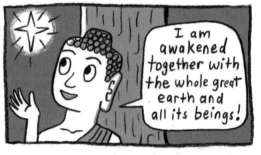

Every December 8th we commemorate Shakyamuni Buddha's enlightenment by sitting in meditation all night. In Japanese-style Zen temples this night is called Rohatsu.

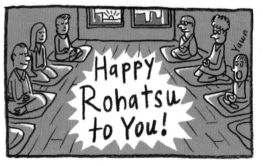

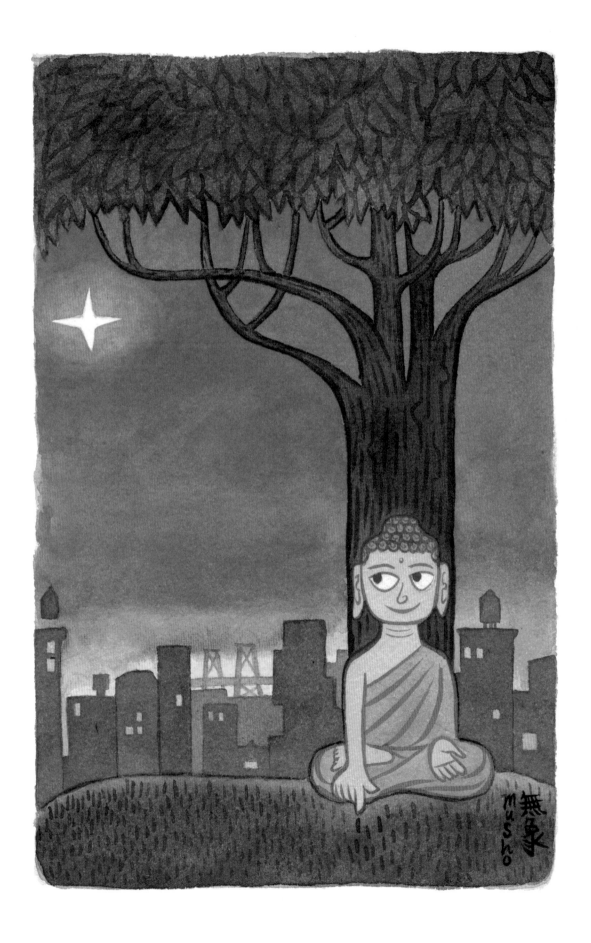

STUDY YOUR SELF

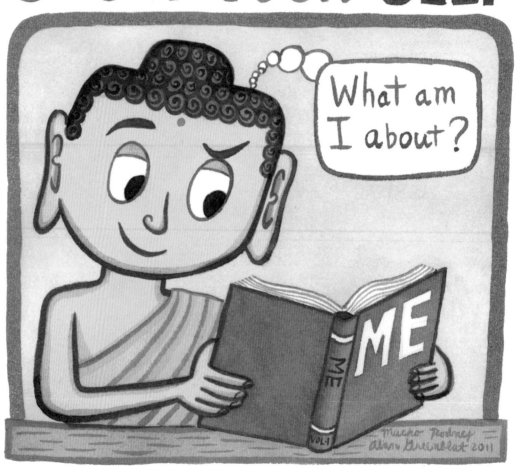

STUDY YOUR SELF

The great teacher Dogen Zenji lived in Japan 814 years ago.

Dogen Zenji
1200 - 1253

To study the Buddha way is to study the self. To study the self is to forget the self. To forget the self is to be actualized by the myriad things.

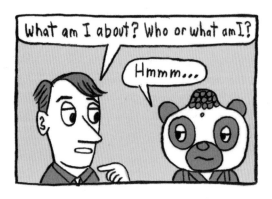

What am I about? Who or what am I?

Hmmm...

Are you a human being? Are you a son, a brother, a friend, a husband, a parent? Are you an artist and a designer?

Yes.

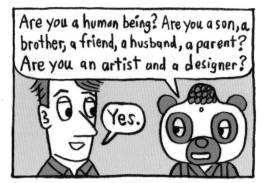

Are you a tourist, a music fan, a tax payer, a computer user, a customer at a store, a person walking a dog?

Sometimes.

So I guess I am all of those identities depending on time and circumstance.

Yes...

And you are FREE of ANY of those identities!

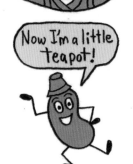

Now I'm a little teapot!

To study the self is to look at something that is changing all the time. When the idea of a solid self is forgotten, the circumstance and need create who you are. Dogen says the myriad things are actualizing you at every moment.

To study the self can be a difficult task, but it is well worth doing. Looking carefully at the self can reveal the causes and conditions of so much of our collective suffering as well as our collective joy.

The best way to study the self is in meditation.

PLANT STRONG

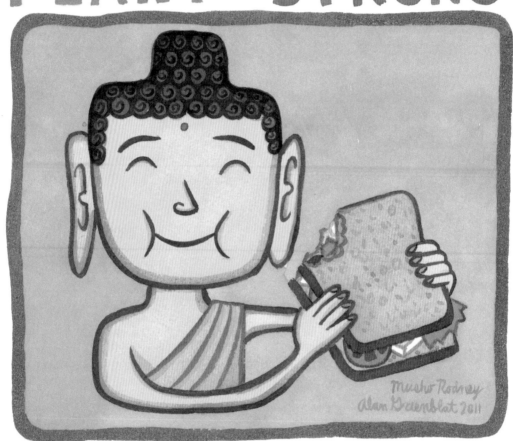

VEGAN SANDWICH

LUNCH

We should know that meat eaters have so many countless offences, thus vegetarians have masses of countless merits and virtues. But the mundane persons do not know these offences of meat eating and the merits of not eating meat, so now I say in brief that I do not allow meat eating.

So it was said in the old sutra, yet vegetarianism is not required to practice the Buddha way. In our temple in New York City only a small percentage of our group has decided on vegetarianism.

I grew up eating meat.
Yum!
Grilled Hot dog on bun.

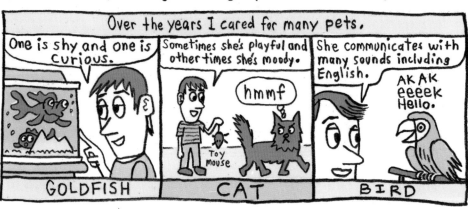

Over the years I cared for many pets.

One is shy and one is curious.
GOLDFISH

Sometimes she's playful and other times she's moody.
hmmf
Toy mouse
CAT

She communicates with many sounds including English.
AK AK eeeek Hello.
BIRD

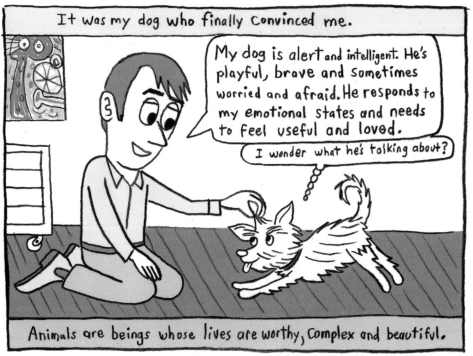

It was my dog who finally convinced me.

My dog is alert and intelligent. He's playful, brave and sometimes worried and afraid. He responds to my emotional states and needs to feel useful and loved.

I wonder what he's talking about?

Animals are beings whose lives are worthy, complex and beautiful.

When I finally made the break to vegetarianism I felt a great freedom. Relief from the moral ambiguity, and release from the troubling cycle of industrial farming. I felt healthier and lighter.

EAT BEANS NOT BEINGS!

Being a vegetarian or a vegan is not easy to do. It pushes against the cultural current, and mindfulness and compromise are constantly required. Even so, it is well worth the effort. The vegan sandwich is waiting, and it is delicious.

23

BE A LAMP

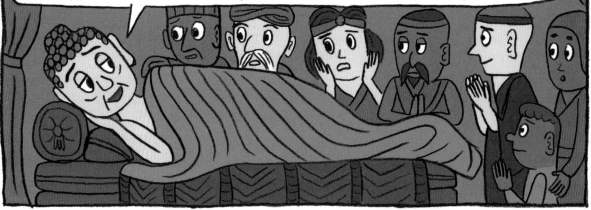

From Buddha's final sermon in the Maha-Parinibbana Sutra

Oh devoted disciples, do not weep after I am gone. You have heard my teachings well, therefore be a lamp unto yourselves. Light your own way and hold fast to the truth as a refuge. Do not look for refuge in anyone beside yourself. That is how you shall reach the highest goal.

This was great advice. The way I read it is that there is no need to follow the opinions or beliefs of others. Inside each one of us are all the needed abilities to make our lives vibrant and valuable. All we have to do is to be open to all the teachings around us and be sensitive to our communities. If we can shine the lamp on our own quality of being, we can solve problems and live in peace.

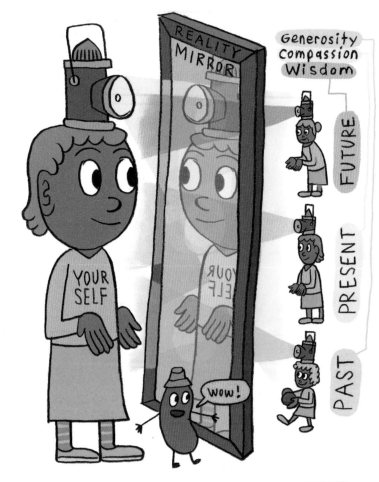

May you be a lamp to yourself and all beings!

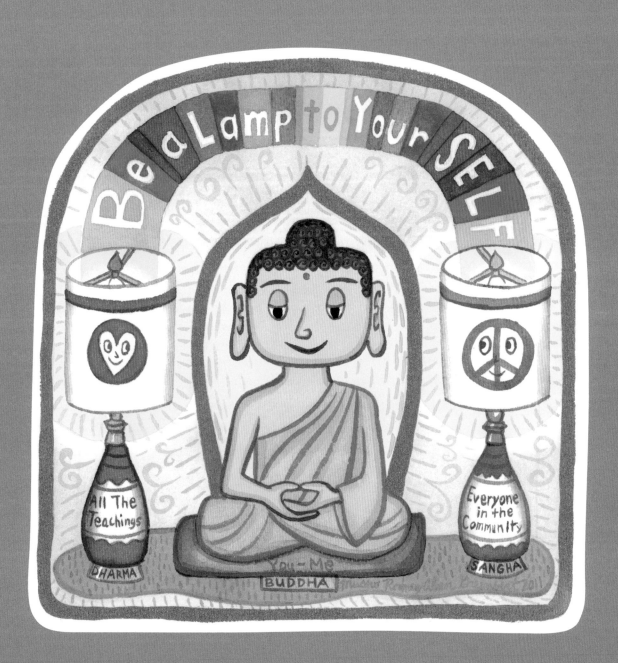

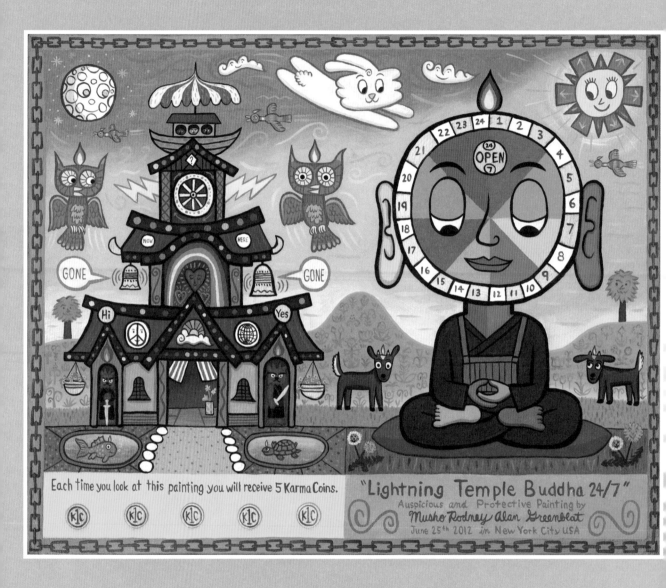

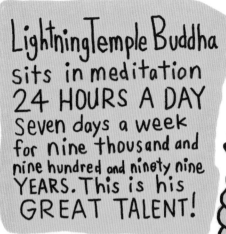

LightningTemple Buddha sits in meditation 24 HOURS A DAY seven days a week for nine thousand and nine hundred and ninety nine YEARS. This is his GREAT TALENT!

I don't need any clocks so I can relax.

All things are changing ending and starting again. This is the non-stop way. Another moment just passed.

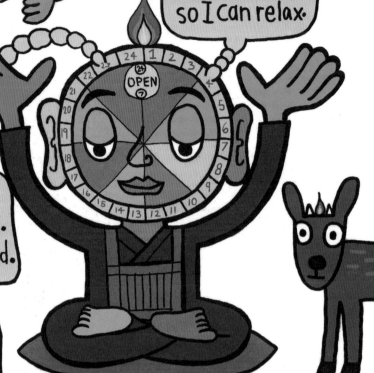

The Lightning Temple appears SUDDENLY in a flash, and then dissapears and then reappears a moment later. It happens so quickly that it seems to be standing still.

Perhaps the Lightning Temple is not there. Perhaps LightningTemple Buddha is not there either.

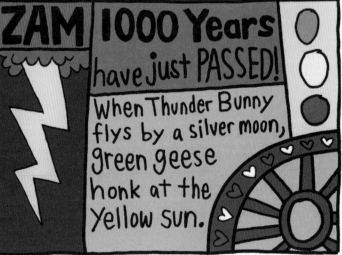

ZAM 1000 Years have just PASSED! When Thunder Bunny flys by a silver moon, green geese honk at the yellow sun.

HOW MARVELOUS

The Great Marvelous Bodhisattva Moment Protector → Little fluffy white cloud → Pile of gold, gold and more gold → Silver bathtub filled with restless ocean water → Ancient tortoise Symbolize Longevity Orbit Wanderer → Constantly burning candle that not only lights the way.

The Great Marvelous Bodhisattva Moment Protector has eight arms:

 1 and 2 are folded into the cosmic mudra of meditation.

 3 holds the Very Loud Wake-up Bell, which keeps ringing and ringing as an aid to beings who are groggy or unenthusiastic.

 4 holds the Real Mirror that symbolizes the empty nature of reality, and at the same time is a real mirror that can be used for reflection.

 5 holds the powerful Blow-dryer of Delusion that blows away obstructive clouds.

 6 holds the powerful Anti-Demon Flashlight that exposes and embarrasses the demons of deception.

 7 supports the humble community center, where meetings of all kinds are held, where grievances are aired, shared interests are explored, and parties celebrated.

 8 holds the legendary Wish Fulfilling Jewel.

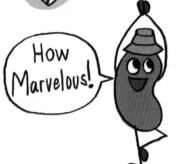

How Marvelous!

If you see Great Marvelous Bodhisattva Moment Protector in the sky, strike a standing yoga pose and shout "HOW MARVELOUS!" Then your troubles will become welcomed opportunities, and your family and friends will all smile at you with pride.

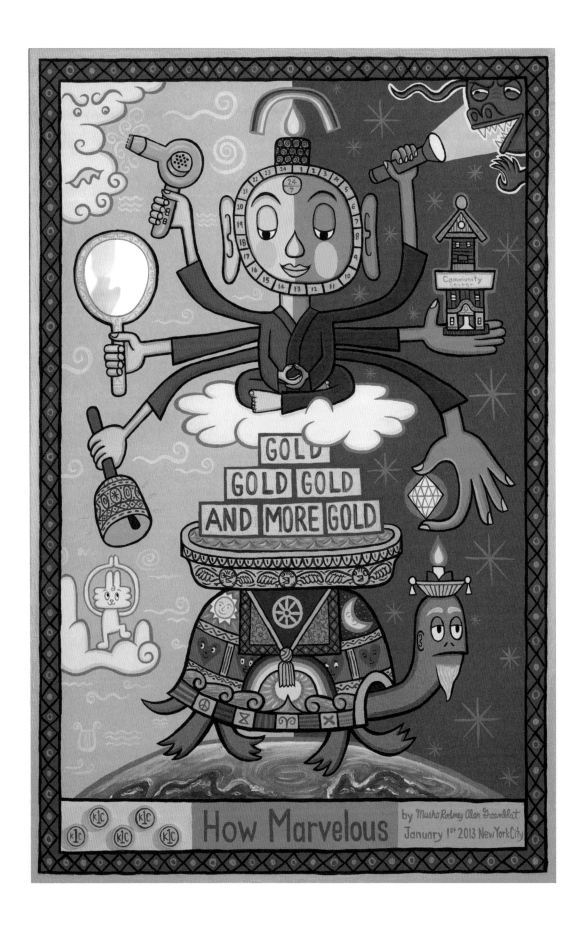

29

Unlimited Faith Offering

You are the Great Fully Grateful One riding on above and inside the shining blue globe of the world. Your starship is called The Selfless-Self.

Boundless

--KARMIC SHIFT--

Birth

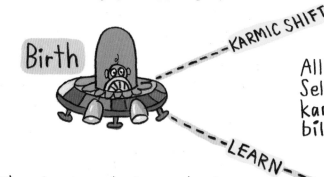

All things fit in the ship of Selfless-Self which has the karma capacity of nine hundred billion beings.

--LEARN--

Awareness

The steering wheel is made of gold and the control panel is silver with the various buttons and knobs made of rubies, emeralds and wish fulfilling jewels.

--PRACTICE--

Help Others

Twinkling stars are also beings, reflecting on the ocean, river and lake, scattering into more millions of stars as the ripples tumble on the surface.

--ACTUALIZE--

The Wisdom and Compassion lamps shine down in bright beams. Powered by lotus willpower they last anywhere from five seconds to five thousand years.

Death

--KARMIC SHIFT--

Boundless

The starship sails slower than slow, faster than fast, into the day and night with continuous motion. Steady at the wheel, the bright Selfless-Self becomes unnoticeable.

AS IT IS

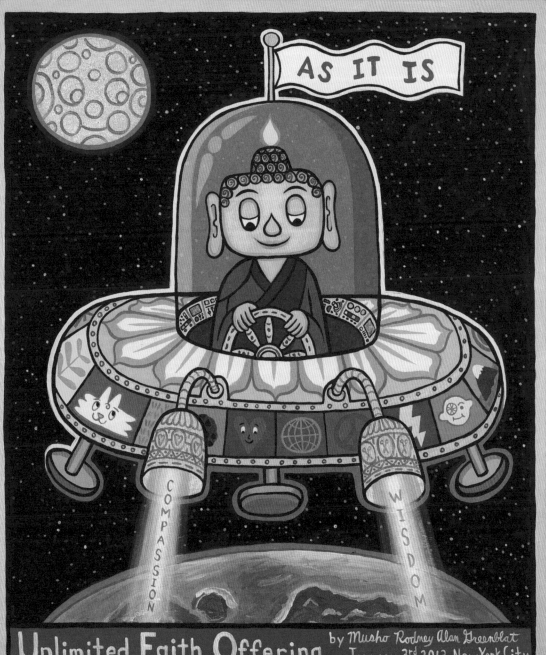

AS IT IS

COMPASSION

WISDOM

Unlimited Faith Offering

by Musho Rodney Alan Greenblat
January 3rd 2013 New York City

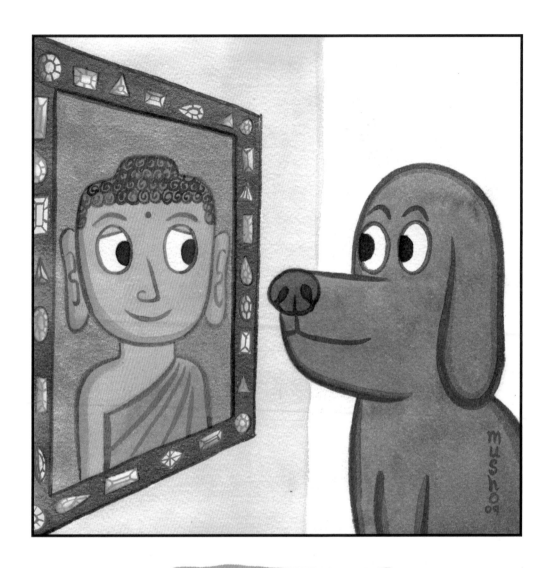

MIRROR NATURE

When looking in the mirror it is possible to see a Buddha. Even so, it is very difficult for human beings. Those who want to see a Buddha in the mirror can never see a Buddha. A dog can see a Buddha in the mirror, but has little reaction. Why is this? Because it doesn't matter to a dog whether a dog is a Buddha or not.

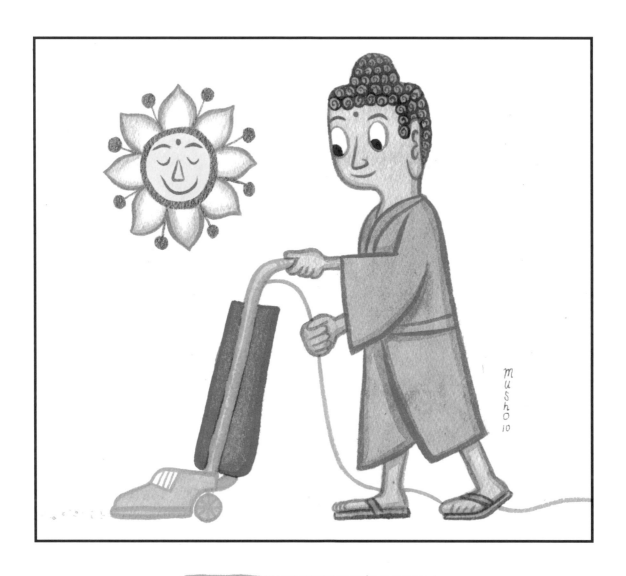

BUDDHA VACUUMING

Hello dirt. I'm sorry you cannot live here on the floor of our home. Wouldn't you rather be outside with the other soil, helping plants and trees to grow, or participating in a new landfill mountain? Instead of being stepped on and disliked here on the floor why not live with dignity as part of the great earth? The vacuum bag will transport you.

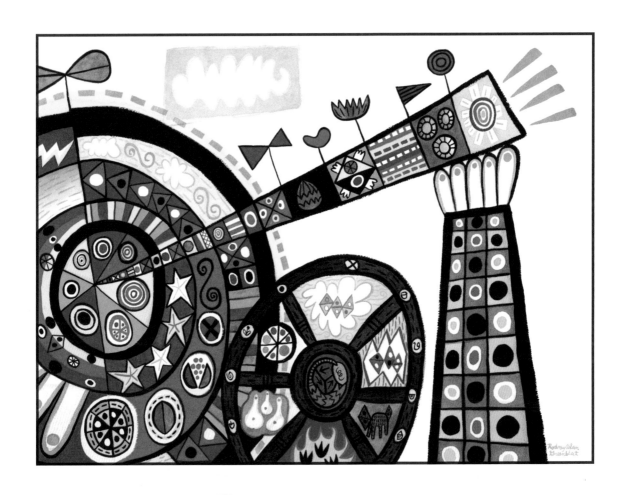

TRUMPET OF BUDDHA

It is not difficult to hear the trumpet sound, even if one is standing on the distant shore. It is not difficult to see the wheels turning even if they are disguised.

It is not difficult:

to smell and feel the cool breeze of heaven
to smell and feel the fighting of the titans
to smell and feel the animals roaming the woods
to smell and feel the burning fire in hell
to smell and feel the desire of the hungry ghosts
to smell and feel the suffering of the human world

It is not difficult to play the trumpet or turn the wheel yourself, but it does require practice. At first it will seem impossible. It will take time to find a patient teacher. Even when you become proficient, you will feel inadequate. Even so, do not give up. In time, it will not be difficult.

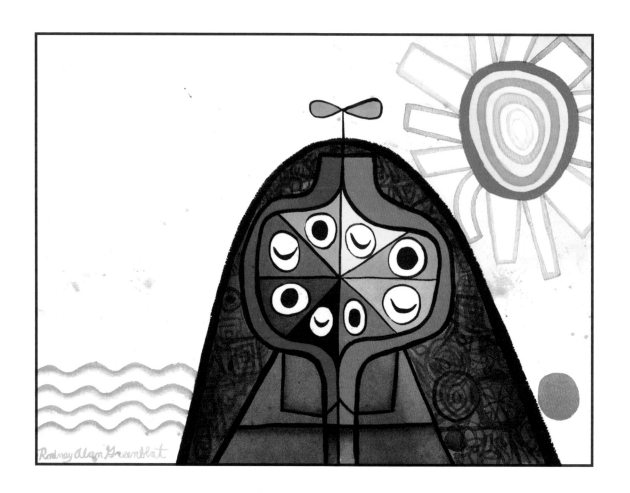

SITTING IN THE MOUNTAIN

It is common for those who have attained some wisdom to retreat into the mountain and stay there for one thousand years. During this time they benefit from solitude and contemplation, gain insights and patience.

When they return from the mountain they see that the world of desire and grasping has not changed, and if they really have learned anything they start working toward the benefit of all beings. As they do their work, often without notice or recognition, another ten thousand years goes by. During this time many of the people they meet are inspired and attain some wisdom themselves. These people also retreat into the mountain and begin the cycle again. In this way more and more wisdom is attained, and more and more beings benefit.

BUDDHA TIME PROJECTOR

There are two wheels: the upper Everyday Perception Wheel and the lower Actual World Turning Wheel. As the two wheels use complementary energy they alternate in lopsided rotation. The in-breath generates beautiful growing gardens of flowers, trees and all beings. The out-breath expands the earth kindness cycle of beginning and end.

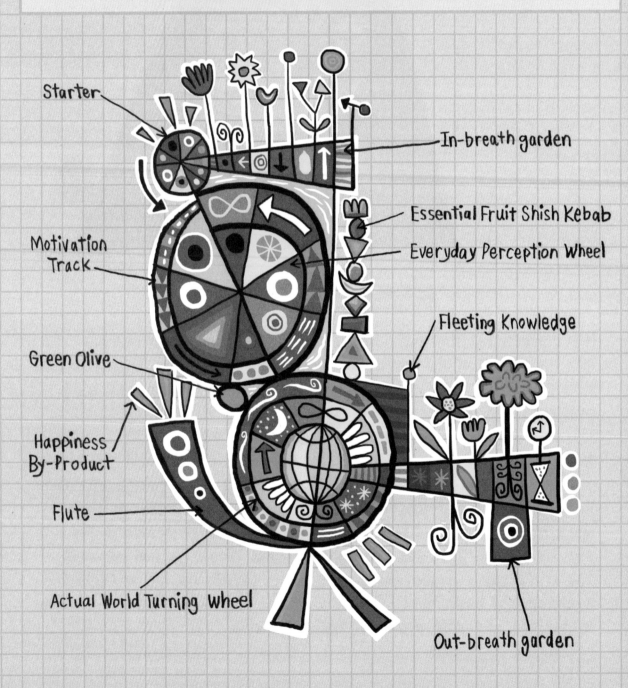

Starter

In-breath garden

Essential Fruit Shish Kebab

Everyday Perception Wheel

Motivation Track

Fleeting Knowledge

Green Olive

Happiness By-Product

Flute

Actual World Turning Wheel

Out-breath garden

BUDDHA SPACE PROJECTOR

A pink funnel collects all the particles of the universe into the delicate spinning planet earth, which causes the star wheel to rotate around the matter wheel. The dimensional force is sent up through the cool warmer and into the day-night quiet chamber. Ordinary forms escape out the main outlet, and laughs through the secondary port.

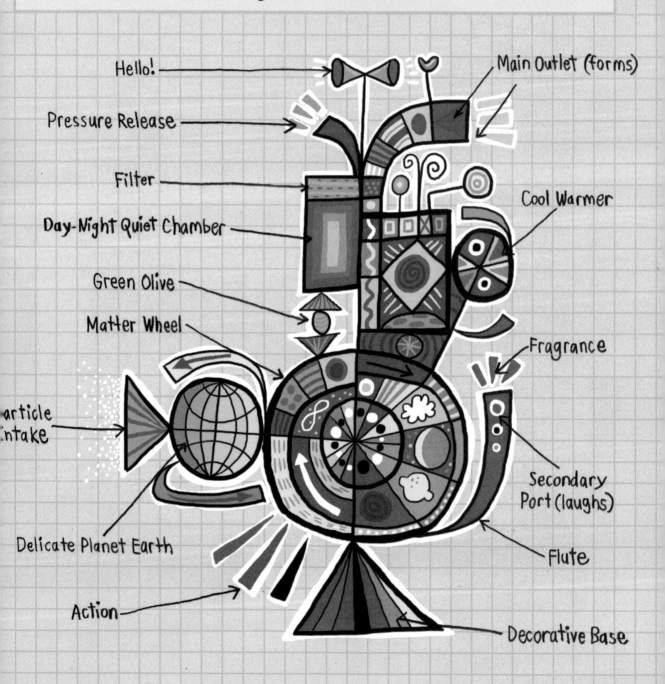

Hello!

Pressure Release

Filter

Day-Night Quiet Chamber

Green Olive

Matter Wheel

Particle Intake

Delicate Planet Earth

Action

Main Outlet (forms)

Cool Warmer

Fragrance

Secondary Port (laughs)

Flute

Decorative Base

THE WOW TEMPLE

HISTORY

Founded on the date of birth, the temple has been in operation every day of existence. Over the years it has gone through varying periods of popularity or obscurity, but has managed to thrive with the help of caring participants and benefactors. The many renovations and re-inventions of the temple have helped it stay open in the current moment. Passing through a modest childhood, a rocky adolescence, and a promising young adulthood, the Wow Temple is now a place of contemplation in the vast field of maturity.

FEATURES

The central form of the temple is the Giant Golden Buddha. Made of bronze and gold, its true nature is not affected by the elements or the comings and goings of political dynasties. Although the fashions and cultural currents of the surrounding areas change, the Buddha remains the same. The temple is proud to offer a wide array of services, with teachings for all levels of understanding, accommodations for guests, a library, a nutrition center, a gym, and space for leisure and meditation.

VISITING

The temple is open 24 hours a day, but the night is usually reserved for sleeping, and not all services are available at that time. Wear comfortable practical clothes while on the temple grounds, and limit speaking to only what needs to be said. At designated times singing and poetry are allowed. Visitors are asked to soften their expectations, and be open to whatever is presented. Littering is not allowed. Smiling is encouraged. Your generosity allows the temple doors to stay open.

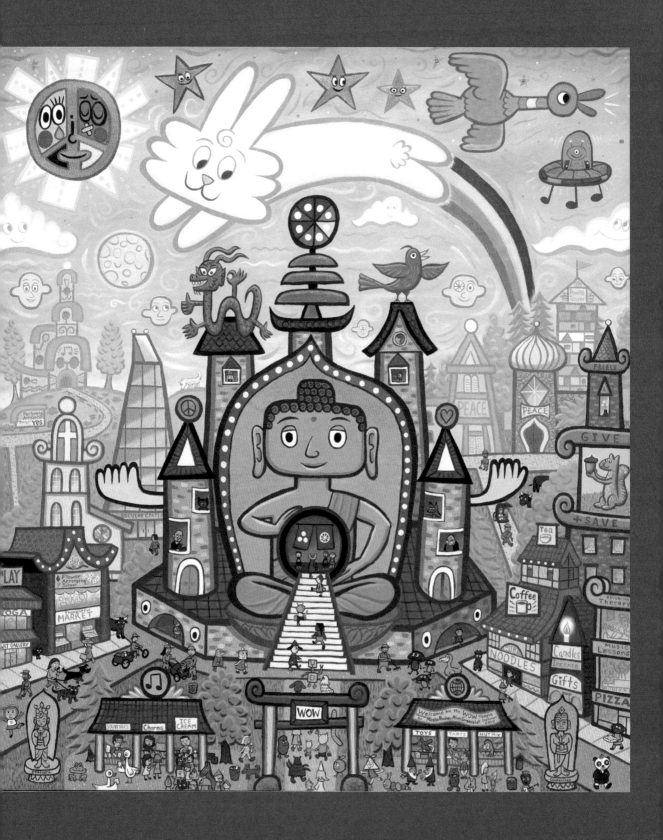

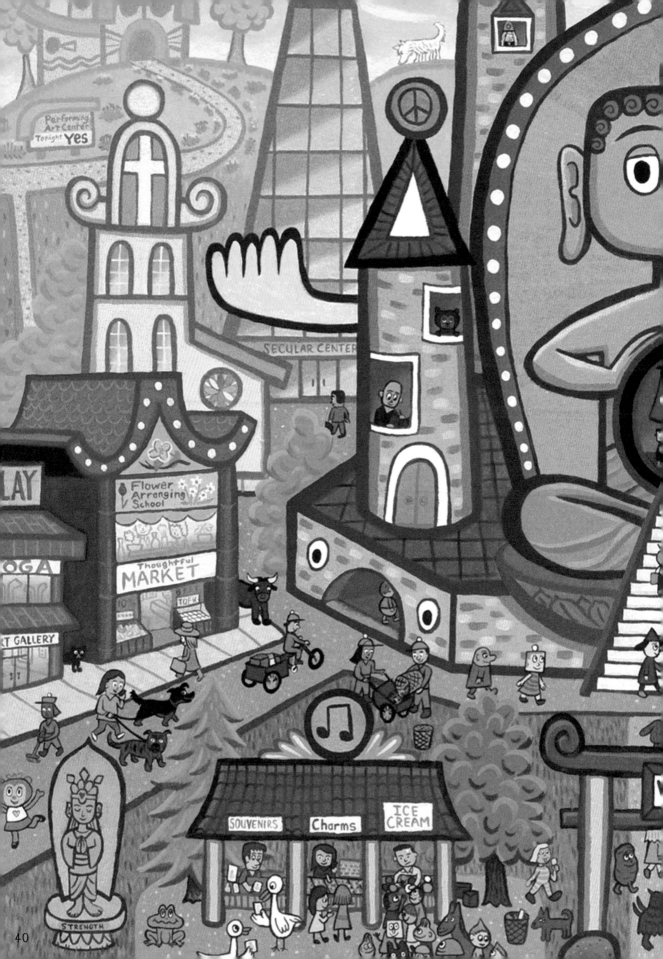

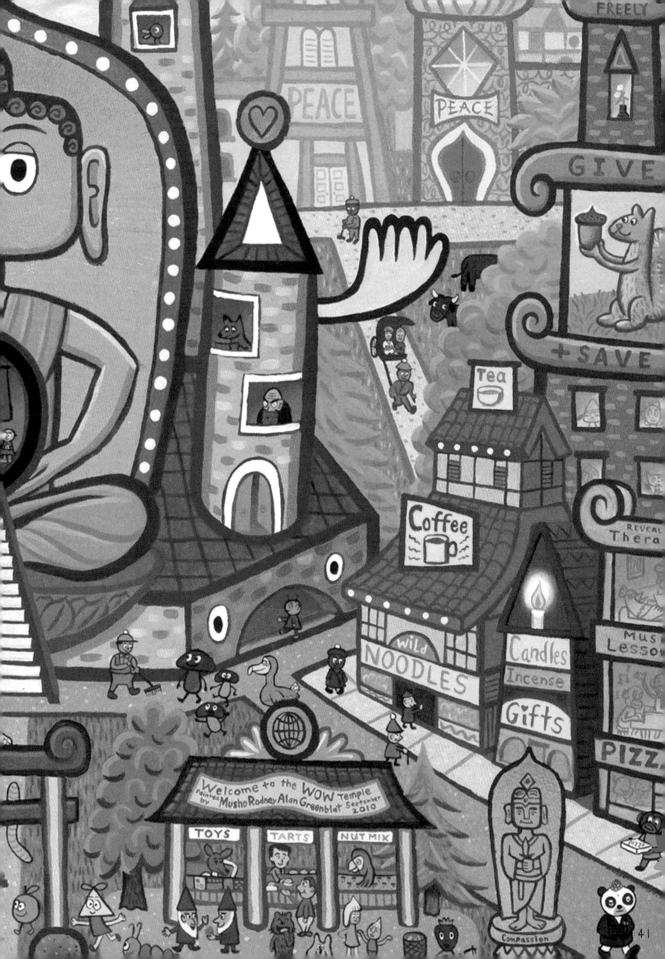

41

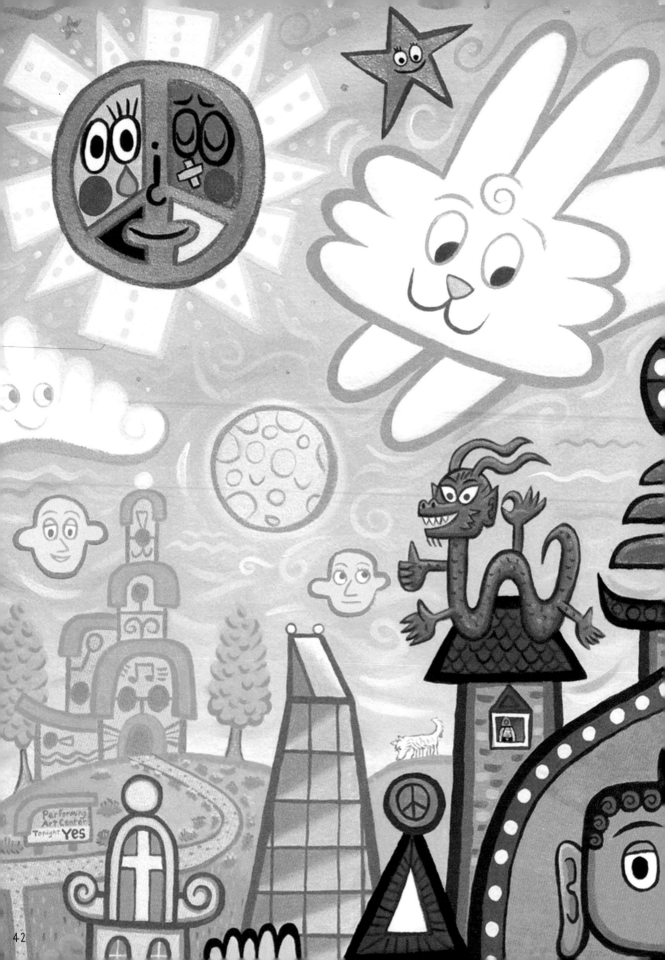

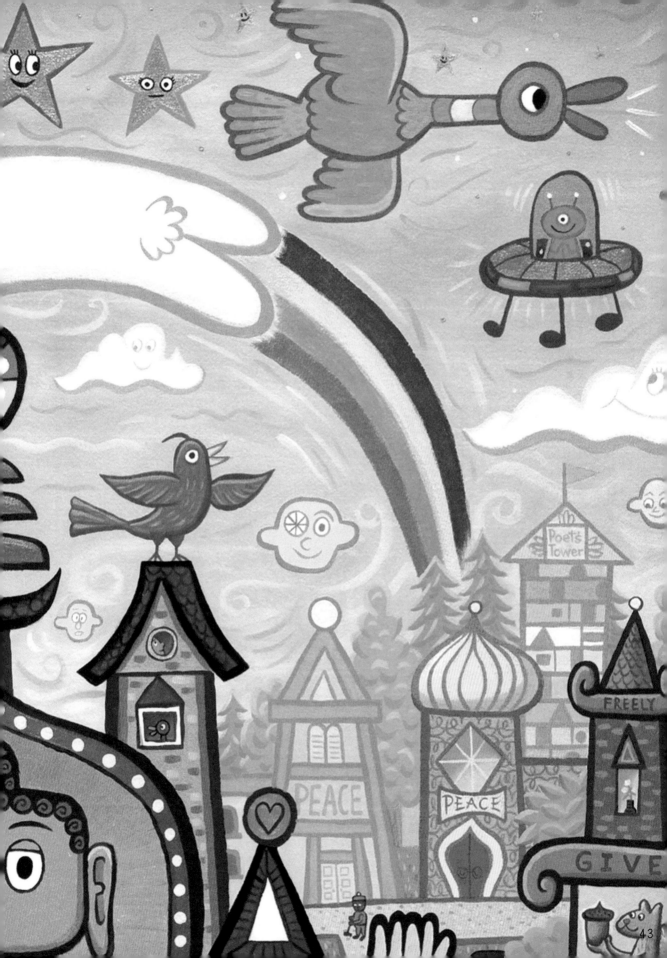

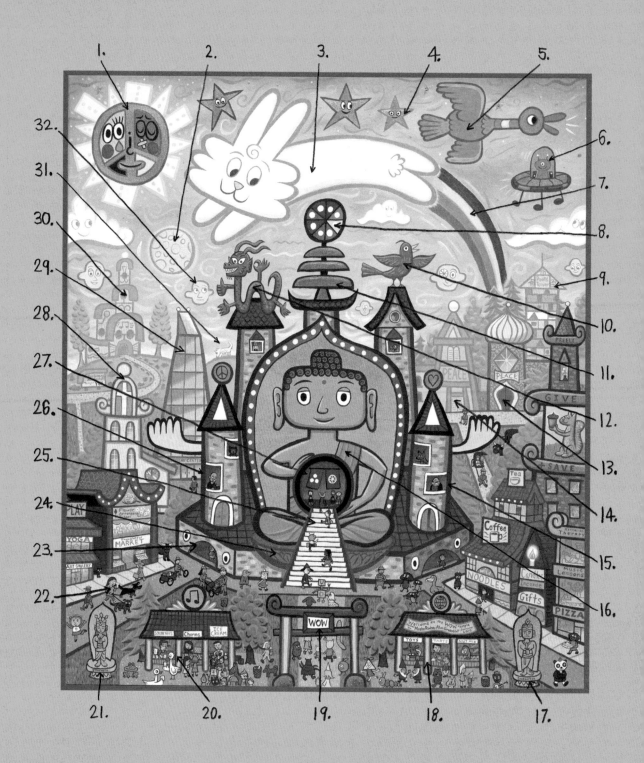

WOW TEMPLE KEY

1. Being Peace Sun. Eyes open on one side, closed on the other with tear, injury and smile
2. Sleepy moon still visible in the day sky
3. Thunder Bunny cloud deity offering help, good cheer and special powers
4. Three silver stars trimmed in red, blue and green
5. Wild Great Green Goose. Who knows where she flies to?
6. Visitor from another world who is curious about our customs
7. Rainbow trail of Thunder Bunny as he flies through the sky
8. Eight-sectioned clock—or pizza in this case—representing the eight fold path
9. Poet's Tower is a special government supported lifetime residency for poets
10. Bluebird of Happiness giant rooftop inspirational figure
11. Triple giant gold bell that rings at meditation time three times a day
12. Green Dragon of Enlightenment giant rooftop inspirational figure
13. Islamic peace and worship center
14. Jewish peace and worship center
15. Bodhidharma appreciation tower
16. Great Buddha of the Wow Temple
17. Golden Compassion Statue for men
18. Merchants pavilion featuring Tuna's Toys, Deena's Vegan Tarts, and Cosmo's Nut Mix
19. Main Gate of the Wow Temple originally built in 1242
20. Merchants pavilion featuring Rodney's Souvenirs, Kim's Charms, and Tak's Ice Cream
21. Golden Strength Statue for women
22. Cleo walking Zev and Pogo
23. Entrance to the lower level visitor center and auditorium
24. Great Lotus Salad Bowl
25. Great Silver Stairway
26. Dogen appreciation tower
27. Main entrance to the grand lobby and meditation hall
28. Christian peace and worship center
29. Secular peace and introspection center
30. Performing Arts Center
31. Loki
32. One of the Five Lemons of Satisfaction

Bodhisattvas are enlightening beings who have vowed to:
 1. Save numberless Sentient Beings
 2. End inexhaustible desires.
 3. Master all boundless Dharmas.
 4. Attain the unattainable Buddha way.

As they practice these vows they work diligently
with all their abilities to give others the opportunity
to enter the realm of ease and freedom.

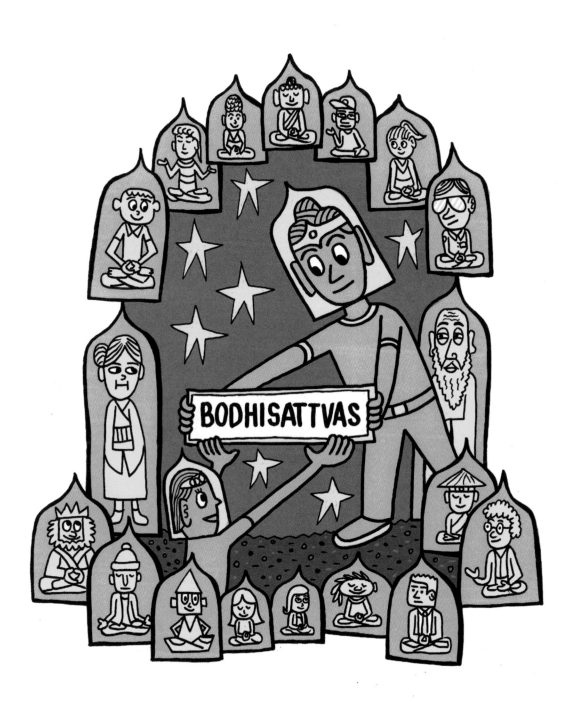

Hello! I am Manjushri.

Prince of Wisdom.

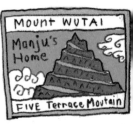

MOUNT WUTAI
Manju's Home
FIVE Terrace Mountain

My mission is to deliver wisdom and save all sentient beings.

How do I do this?

1. Ride swiftly on a <u>Lion</u>. His name is Reginald. He is noble and fearless.

2. Wield the sharp <u>Awareness Sword</u>.
 It cuts through red tape and blue tape.
 Red: aversion, anger, greed, ignorance.
 Blue: desire, conceptual thinking, self image.

3. Carry a clarifying <u>Wisdom Text</u>.
 It says all beings are unique.
 It says all situations are unique.
 It says share SKILL, COMPASSION and INSIGHT.

Reginald

4. Understand:

Or try it like this:

5. Remain open/steadfast.
6. Remain brillant/humble.
7. Remain spontaneous/mindful.
8. Remember:

Nowhere to arrive to.
Nothing to attain.

NOTE:

Being wise and powerful, I sometimes take the form of a small brown sparrow.

9. Travel from place to place throughout space and time cutting through the obstructions that prevent the flowering of joyous self-liberation.

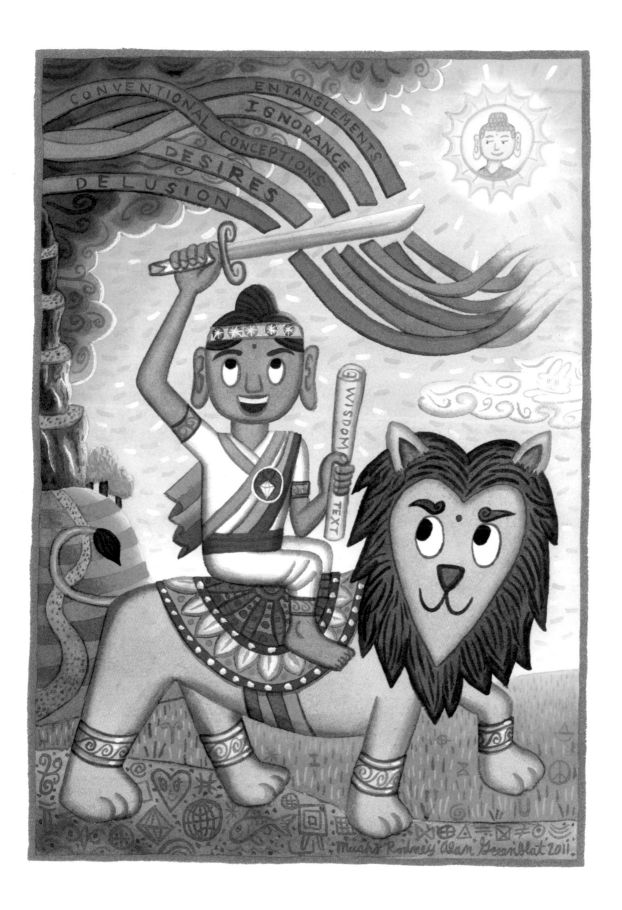

49

Hello! I am Samantabhadra! ← "Universal Virtue"
I embody the limitless power of VOW.
How do I do this?

SAMANTABHADRA
enlightened
BODHISATTVA

Steadfast Effort! Untiring Strength!

GREAT DIGNITY

eye
ear
nose
tongue
body
mind

RADIANT ABILITY

I ride upon my unstoppable white six-tusked elephant! Each of the six tusks represents one of the senses with the power to overcome the imperfect nature of perception.

10 VOWS OF SAMANTABHADRA

1. Respect all the Buddhas
2. Praise all the Buddhas
3. Make generous offerings to all the Buddhas
4. Repent misdeeds and evil karmas
5. Rejoice in others' virtues and happiness
6. Request that Buddhas continue teaching
7. Request that Buddhas continue to remain in the world
8. Follow Buddha's teachings
9. Benefit and accommodate all living beings
10. Transfer all merits for the welfare of all living beings

D.D. BEST ♥

Lets try!
We can do it!

If you fulfill just one of these vows you will achieve enlightenment without a doubt. How much more so if you attain them all!

As I ride across the world, Shakyamuni touches the mountain where Mara the demon of desire hides in fear. Monks smile as I ride by, and Greed, Anger and Ignorance cower and scurry away.

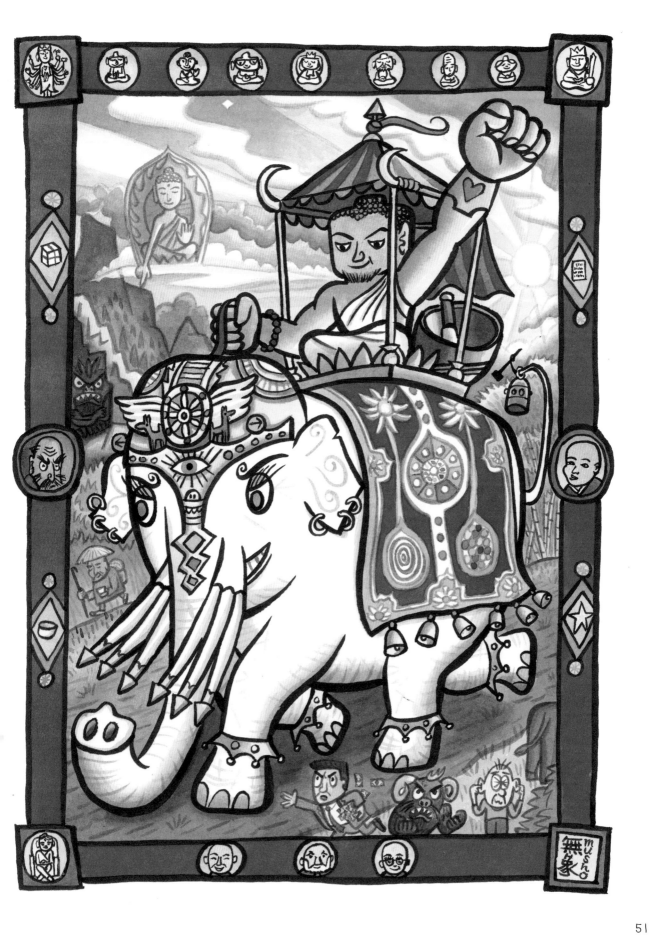

51

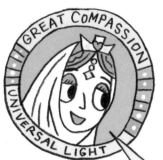

GREAT COMPASSION · UNIVERSAL LIGHT

Hello! I am AVALOKITESHVARA!

"Lord who gazes down at the World"

I embody limitless and practical COMPASSION. I hear the cries of all the suffering beings, and I respond and assist with appropriate means. How do I do this?

Tell me what you need. I am always here to help!

I have many hands. Sometimes twenty, forty, one hundred or even one thousand. In each hand I hold a tool, implement, instrument or material that I can offer to anyone in need.

DharmaDelight's Avalokeshvarha holds in her hands:

1. Sword for cutting delusion
2. Bugle to sound the call
3. Pencil to write and draw
4. Pagoda of serene meditation
5. Office building of valuable work
6. Mirror of wisdom and contemplation
7. Cuddly gift of kindness
8. Pillow to rest your head
9. Fruit for health and nourishment
10. A bowl of pepper
11. A bowl of salt
12. A glass of water
13. Rope for climbing out of trouble
14. Dharma wheel of Buddha's teachings
15. Gold for economic relief
16. Bell to signal change
17. Smartphone for many connections
18. Book of poetry to enjoy
19. Rechargeable drill for building
20. Wish-fulfilling Jewel.

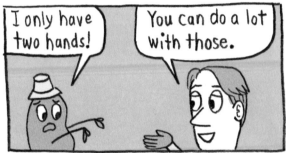

I only have two hands!

You can do a lot with those.

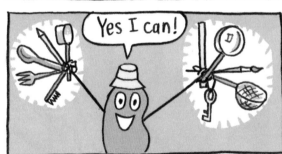

Yes I can!

Kanzeon! At one with Buddha! Directly and indirectly Buddha, Dharma, Sangha. Joyful pure eternal being! Morning mind is Kanzeon. Evening mind is Kanzeon.

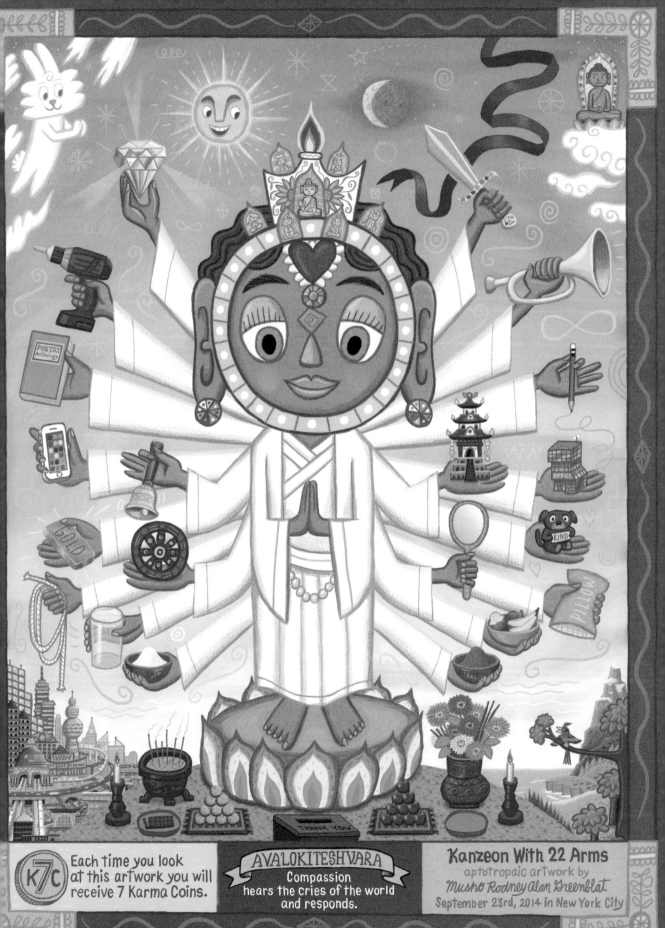

AVALOKITESHVARA
Compassion hears the cries of the world and responds.

K7c Each time you look at this artwork you will receive 7 Karma Coins.

Kanzeon With 22 Arms
aptotropaic artwork by
Musho Rodney Alan Greenblat
September 23rd, 2014 in New York City

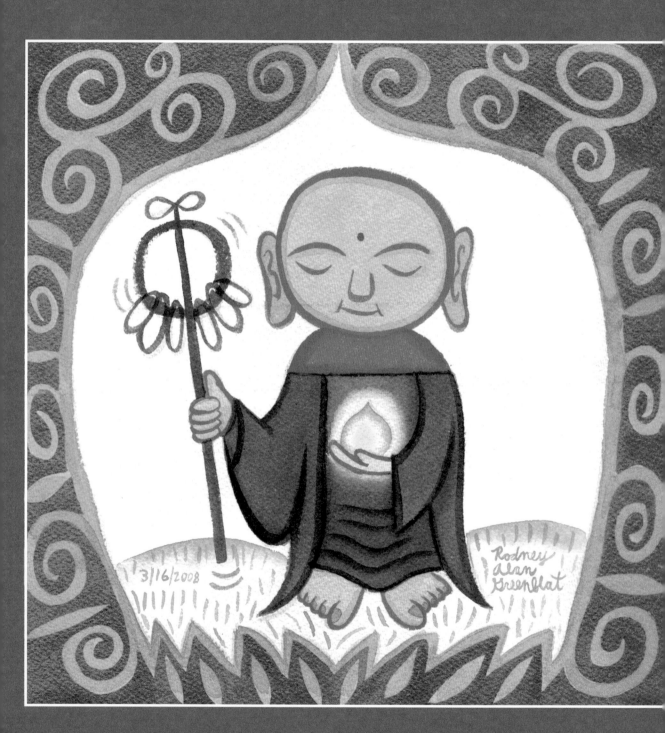

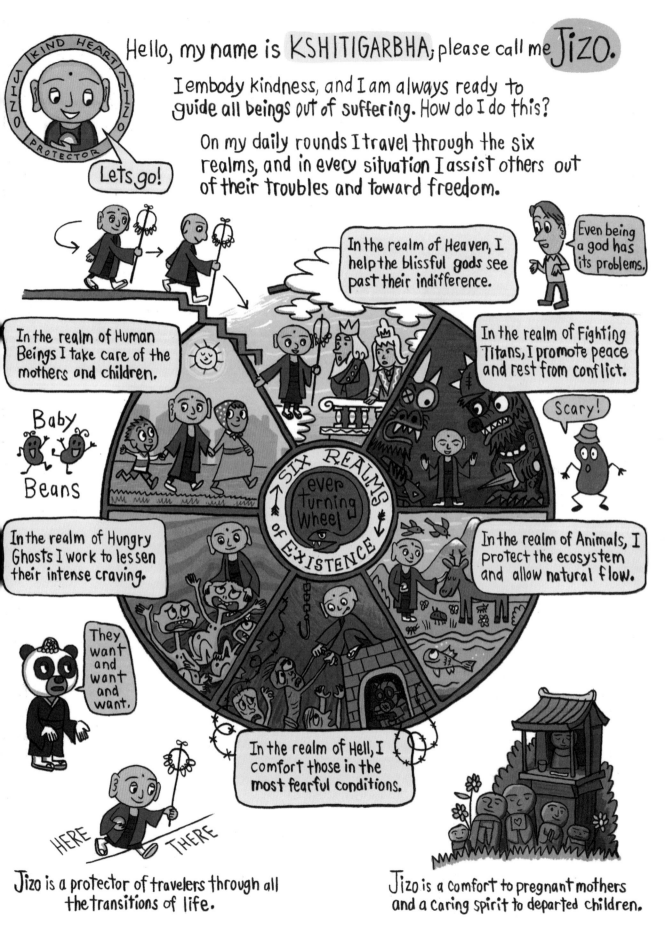

Jizo is a protector of travelers through all the transitions of life.

Jizo is a comfort to pregnant mothers and a caring spirit to departed children.

Dear Buddhas, Bodhisattvas, and all Beings,

I am sorry to say I am ill and resting in bed. The bodily illness that I suffer from is impermanence. The body is a thing that decays in a moment and can not be relied on. It is only an echo, tied to causes and conditions, old age pressing upon it.

I am lonely here in my room, and I wish to invite you all to visit me. Although my room is small it can accommodate as many beings as there are grains of sand in ten thousand Ganges rivers. While you are here we can discuss precepts, meditation, wisdom, emancipation and the insight of emancipation.

Take pity on an old sage and come to my side soon, as time passes like a drifting cloud changing and vanishing in an instant.

Vimalakirti

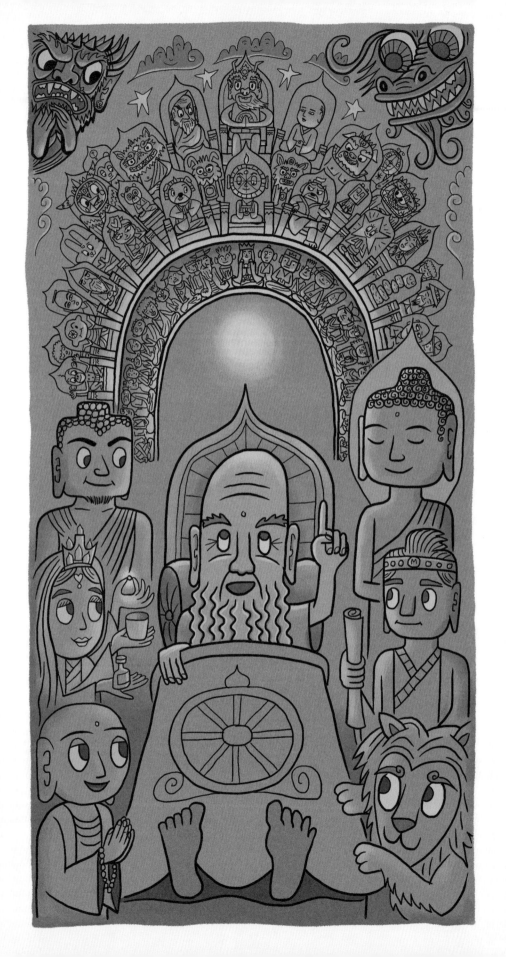

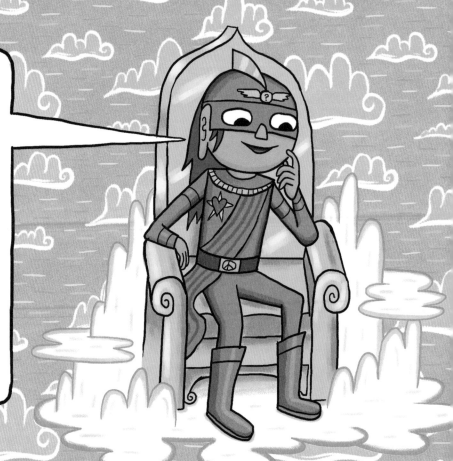

Hello, my name is Maitreya, I am the Buddha of the future whom prophecy says waits in highest heaven for the right time to return to the earth and save all beings.

Maitreya please come now! We need you!

Waiting to materialize?

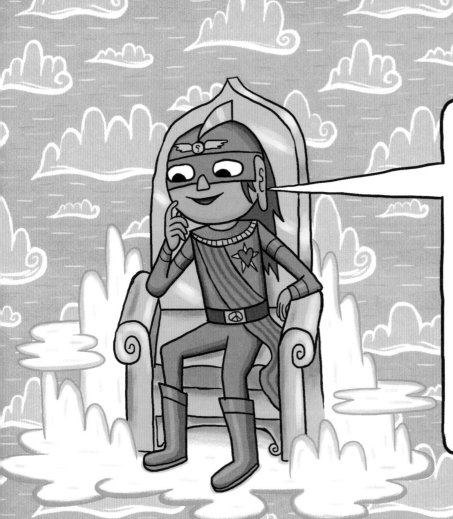

BODHISATTVA YOU

The Bodhisattva's desire is to relieve the suffering of others, and help them to great open awareness. It's easy to do when you are a mythological saint with a hundred arms, or riding a six-tusked white elephant. For average earthly beings the Bodhisattva path is not easy, yet there are average earthly Bodhisattvas all around us. In their everyday activies life is improved in subtle and obvious ways. Look and see yourself and your own activities on the path of universal freedom.

Bodhisattva Endless Effort For Children

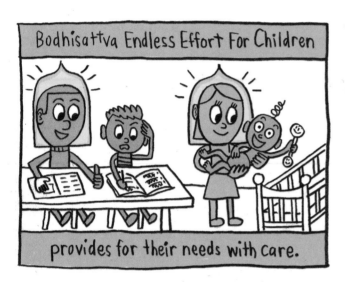

provides for their needs with care.

Bodhisattva Loving Listener to Partner

hears the concerns and dreams clearly.

Bodhisattva Loving Listener to Parents

sees and hears their caring motivation.

Bodhisattva Golden Household Chores

leaves the room neat without complaint.

Bodhisattva Gets to Work Early

is the first one improving the work life.

Bodhisattva Fully Participates

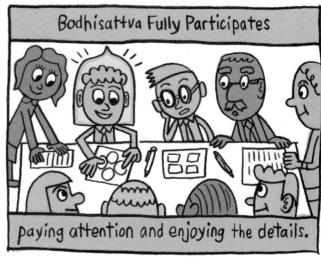

paying attention and enjoying the details.

Bodhisattva Giving Good Guidance

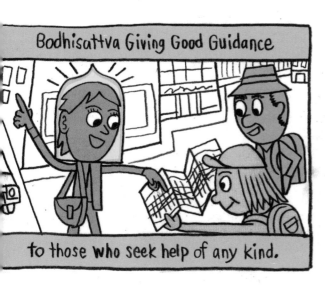

to those who seek help of any kind.

Bodhisattva True Reciever of Assistance

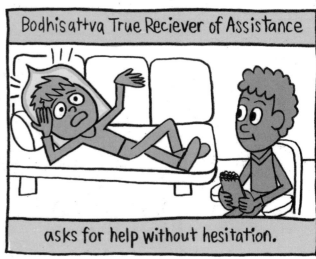

asks for help without hesitation.

Bodhisattva Capable of True Rest

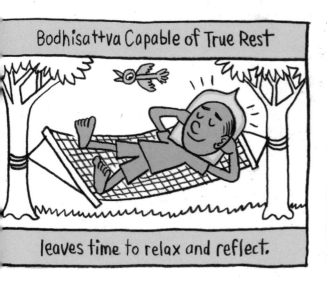

leaves time to relax and reflect.

Bodhisattva Deep Laughs and Smiles

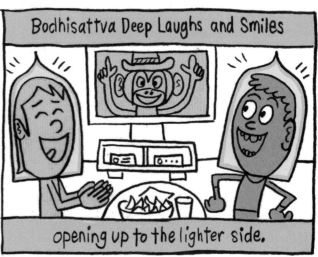

opening up to the lighter side.

At either side of the main gate of temples all over Asia, there are usually two ferocious Dharma protectors. Often with blazing eyes and poses of mid-combat, they conjure the wild spirits of thunder, wind, fire and fierce unbeatable warriors. They are avatars of ancient mythologies from other worlds.

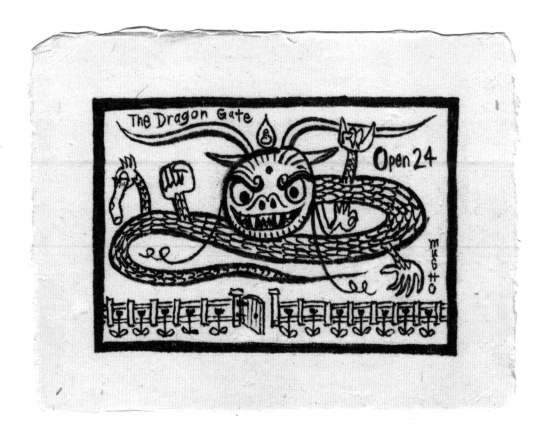

Their purpose is first to frighten away evil spirits and enemies of the temple, then to inspire awe and reverence in all those who enter. They also are there to usher us into the spiritual world of miracles and the unknown, and we must let go of our notions and beliefs before we enter the gate. In this way we may realize that this very everyday world is the world of miracles and the unknown.

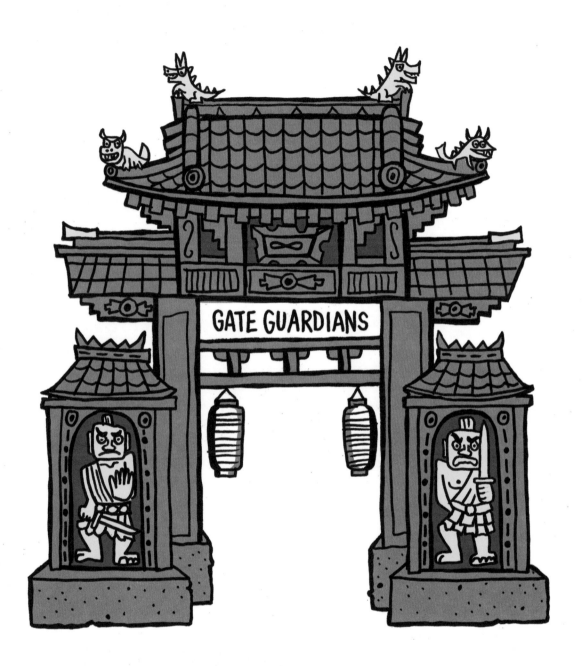

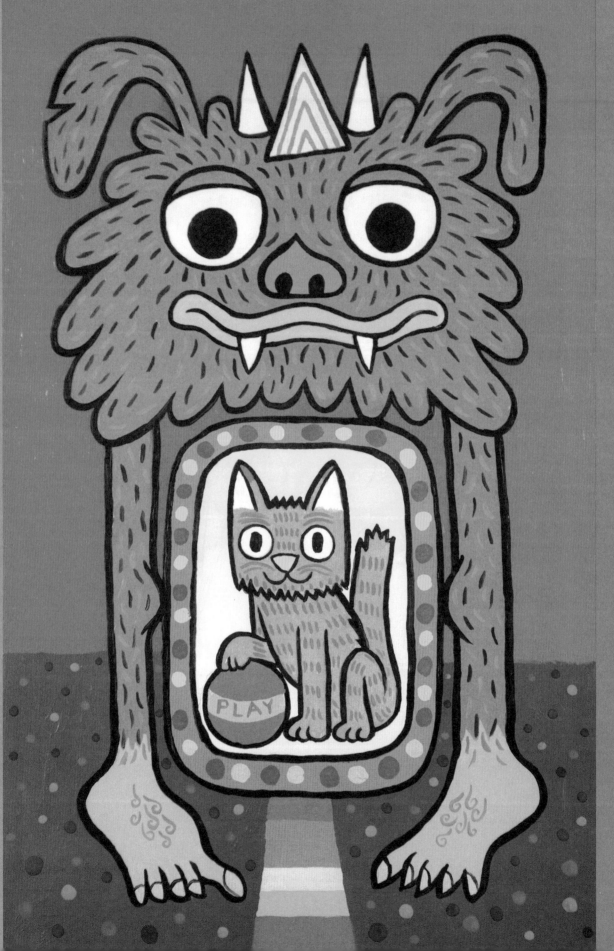

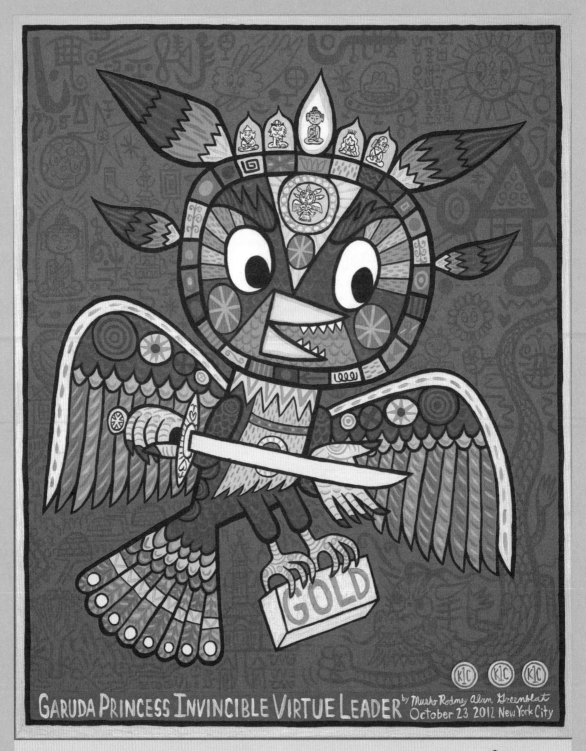

GARUDA PRINCESS INVINCIBLE VIRTUE LEADER by Musho Rodney Alan Greenblat
October 23 2012 New York City

Garuda is a being from Buddhist mythology that resembles a fierce humanoid bird creature. Garuda's flapping wings create hurricane winds, and serpents and fools cower as their gold is snatched away!

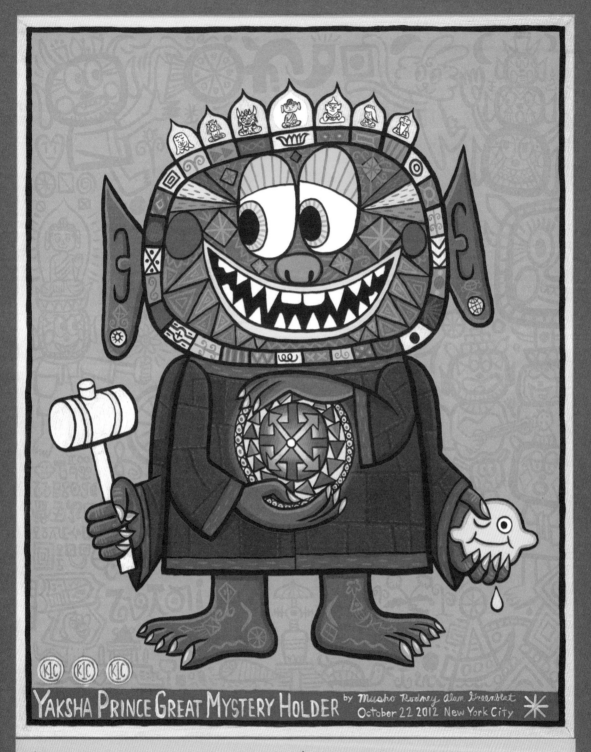

YAKSHA PRINCE GREAT MYSTERY HOLDER by Musho Rodney Alan Greenblat
October 22 2012 New York City

Yaksha is a being from Buddhist mythology that resembles a benevolent demon or troll. Yaksha is a nature spirit protecting the secret object of the forest deep in the tree roots under the earth.

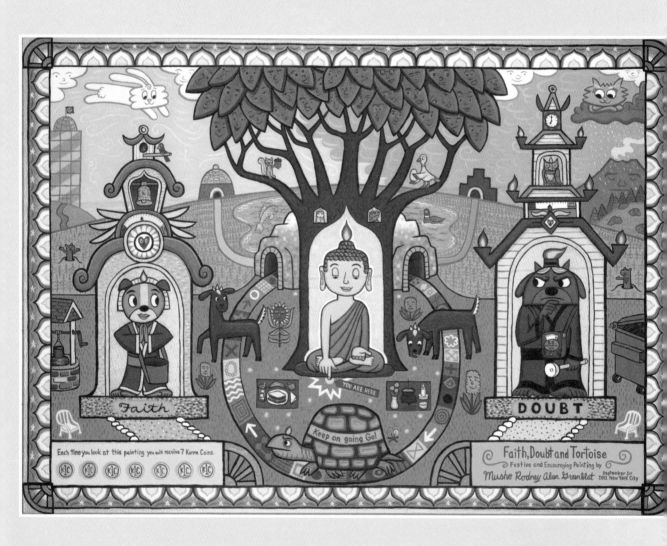

FAITH, DOUBT and TORTOISE

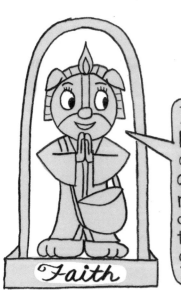

Faith

I'm Faith, gate-keeper of hope and dreams, but also no hope and no dreams. I carry an empty bag open to whatever is offered, for which I am ever grateful.

I'm Doubt gate-keeper of clarity and vigilance. I double check the claims and promises with my sensitive BS detector. I have a flashlight for checking the dark corners.

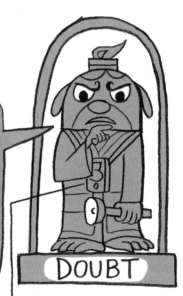

DOUBT

Peace Office Tower built by Faith.

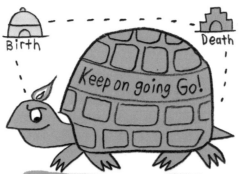

Tortoise walks forever on the circular path of life, in and out of the tunnel of birth and death.

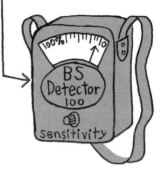

BS Detector 100
sensitivity

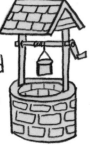

Wishing Well of hopes and dreams.

Offerings to the World Honored One:

Iced tea, banana, tangerine, peanut butter and jelly sandwich.

Flowers, incense candle light and water.

Proverbial Dumpster where everything one day will end up.

Thunder Bunny avatar of Caring.

Faith, doubt and determination are known as the Three Pillars of Zen.

Wonder Mew because a little rain must fall.

x

x

FUDO FREEDMAN THE TEMPLE GATE GUARDIAN

Fudo Freedman is a prince born in the Buddhaland of Peaceful Red Demons, which is an enchanted fire world. At a young age he asked his parents if he could go to Earth.

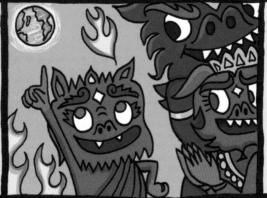

The King and Queen told him he must study the Dharma and all the sciences of Earth before going. When he had studied and passed all the tests of strength and knowledge he came to Earth.

Fudo served as guardian of many great temples until he settled at the FULL EMPTY temple on Wildflower Mountain.

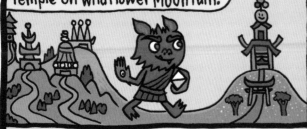

His right hand has the self-seeing eye that is aware of the illusion of "I" and "Me."

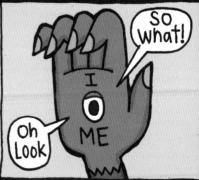

Oh Look

SO what!

Under his foot he protects a bar of GOLD. This reminds him that personal wealth may comfort us, but is ultimately temporary.

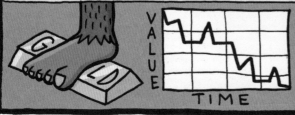

What do you really want?

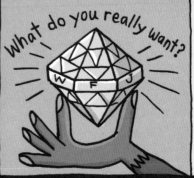

His left hand holds the Wish-fulfilling Jewel that can only be used by Great Wisdom Kings.

Fudo-Myoo is a Japanese name for Acala-Vidyaraja, or Fudo for short. He is a powerful guardian deity often shown engulfed in flames. In Sanskrit his name means "immovable wisdom king".

This is an APTOTROPAIC painting, meaning "having the power to prevent evil or bad luck." This type of art was quite common in ancient times.

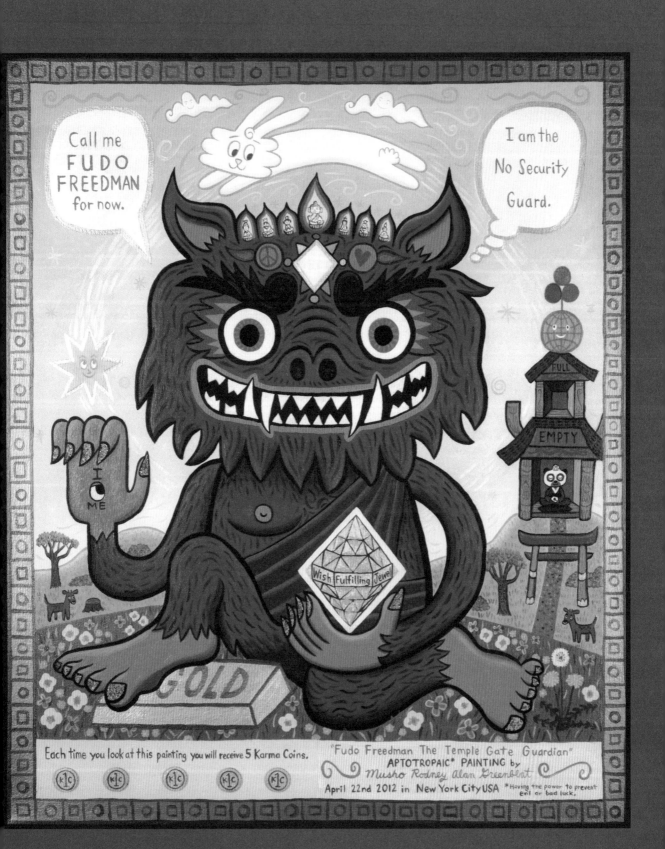

GONE BEYOND DOG KING ZENJI

Gone Beyond was just a pup when he was captured in a battle between envious Blue and Green Gods. The Green Gods sent him to Earth where he was imprisoned in a dog kennel.

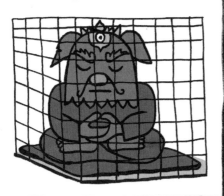

He did meditation in the kennel for 20 years. One day he was discovered by a kindly couple who freed him and gave him sutras and Dharma books which he studied. Soon it was known by all that Gone Beyond was a great Dharma servant king.

Gone Beyond became the Gatekeeper of the Ideal Temple of Heart Hill Valley.

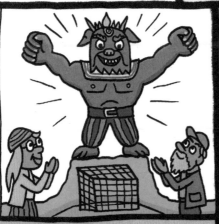

His right hand holds the flaming Dharma wheel of the Eight Fold Path.

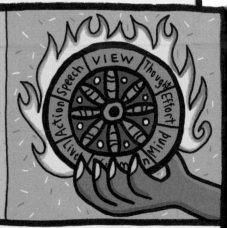

Under his foot he has captured one of the envious Green Gods who forever try to steal gold, but ultimately are never satisfied.

I never get what I want.

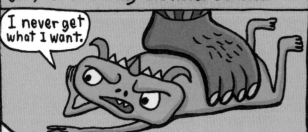

His left hand holds the ordinary flower of Mount Grdhrakutra, that Shakyamuni once used to transmit the True Dharma.

When I grow up I want to wear striped pants and a big belt just like Gone Beyond Dog King Zenji!

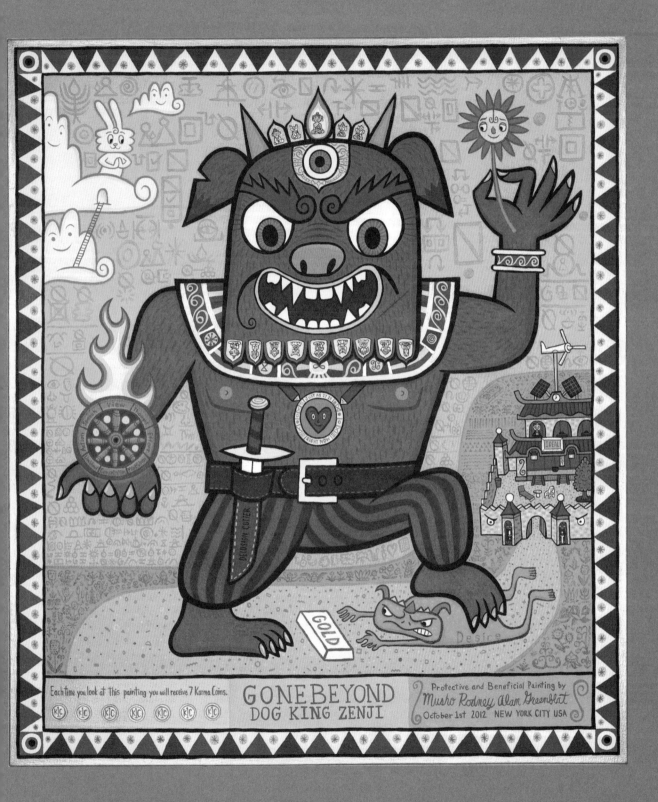

Jataka Tales are very old Buddhist folk stories attributed to the historical Buddha Shakyamuni. The Buddha used many different parables, sermons and stories to teach for over forty years. It was important to him that he address his audience, whoever it might be, at their own unique level of understanding. He lived in ancient India, so he used imagery from stories that ancient Indian listeners would know. The ideas of reincarnation and rebirth were popular in those days, so the Buddha wrote stories of his own innumerable past lives in order to illustrate his teachings in a way that could be remembered and shared.

There are over 500 known original Jataka tales, and in those wonderful stories of the Buddha's past lives he may have been a great king, a simple child, a man, a woman, an elephant, a deer or a bird. Here are two traditional stories and five new Jataka tales written for our 21st century world.

JATAKA TALES

THE PATIENT BUFFALO
(retold from a traditional story)

Once, a very long time ago in a very distant land, the Buddha was born in the form of a mighty water buffalo. His horns were powerful enough to break down trees, and his great hoofs could easily crush rocks. One day, as he lay peacefully napping near the woods, a mischievous monkey appeared. This monkey loved taking risks and testing the anger of the other animals.

"Hey big big buffalo, do you like dancing?" asked the monkey, and then he jumped on the buffalo's back and did a ridiculous dance. The buffalo barely seemed to notice.

"Hey big big buffalo, your horns look like a swing!" said the monkey, and he grabbed the ends of the buffalo's horns and flipped over and over again. The buffalo barely seemed to notice.

The next day the monkey returned, this time determined to make the buffalo angry.

"Hey big big buffalo, meet my wild whacking stick!" said the monkey, and began knocking the buffalo's ears with a thin stick. He then rode all day on the buffalo's back like a hero, holding the stick in his hand. The buffalo barely seemed to notice.

After several days of this treatment there appeared a heavenly being who had been watching all this from above. She said, "Dear Buffalo, with your great strength you could easily end the monkey's games. Why do you let him taunt and tease you?"

"This monkey is small," replied the buffalo, "and he is born with a mischievous nature. Why should I punish him and make him suffer in order that I may be happy?"

The heavenly being then rewarded the buffalo with a magic charm that protected him from suffering and hardship, and he lived a fine and peaceful life. The monkey ran away and found another buffalo to tease, but unfortunately this new buffalo was not as patient.

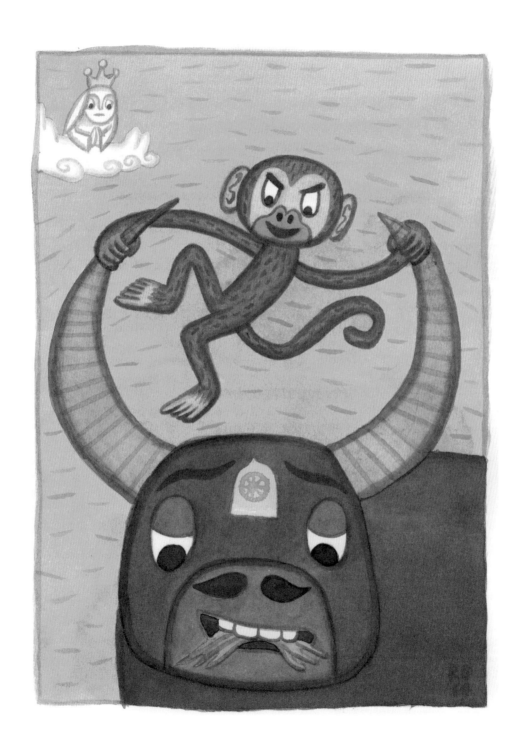

THE TALKATIVE TORTOISE
(retold from a traditional story)

Once, a very long time ago in a very distant land, the Buddha was born as the most trusted advisor to the king. The king had a bad habit of talking too much, and his advisor hoped for the right opportunity to help the king realize his troubling tendency.

At that time there was a tortoise who lived in the marshy valley below the kingdom. One day the tortoise heard two geese chatting. They said, "It's time for us to fly to our fine home in the golden cave of the mountain top." The tortoise heard this and said to the geese, "Can you take me to the golden cave?" The geese discussed it between themselves and then said, "Yes, but can you keep your mouth shut?" "Oh, certainly," he replied. "Hold this stick between your teeth," said the geese, "and we will carry you through the air."

Off they flew from the valley, over the hills and eventually passing over the kingdom. Below, a group of children saw them flying by. One laughed and said, "Look at that tortoise being carried by geese through the air!"

The tortoise, hearing these words, was filled with anger and righteousness. He snarled at them "Why should you care if I am being carried by geese!" Of course, when he said this he lost hold of the stick and fell out of the sky, landing with a loud plop in the muddy sewage cistern of the town. The cistern had stone walls and he could not get out.

The trusted advisor heard about this incident, and knew this would be his chance to council the king. When the king heard the story he knew it was meant as a teaching and warning about his talkativeness.

He said, "My unlimited talking makes it difficult to listen to others, and might lead to the same fate as the tortoise who could not keep his mouth shut. From now on I will speak mindfully and listen carefully." The trusted advisor and all the people of the kingdom were glad, and they lived in peace and harmony for many years.

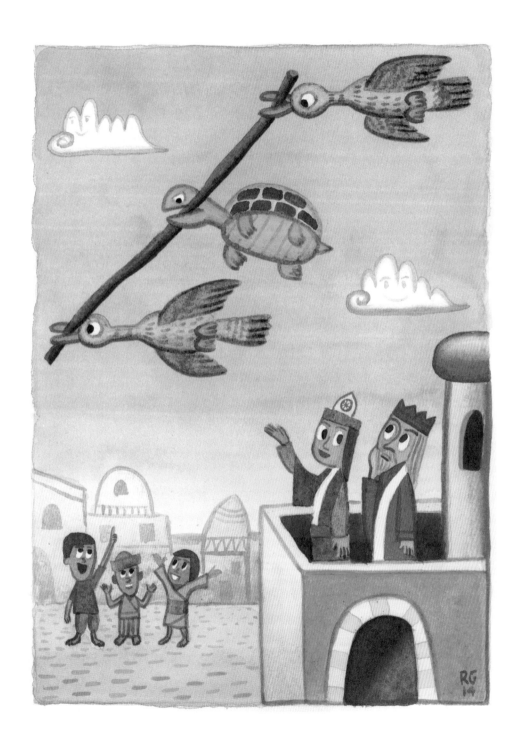

THE THREE WOODCHUCKS

Once, a very long time ago in a very distant land, the Buddha was born in the form of a bowl of hot soup sitting on a stump in the midst of a magical forest. The soup was made of only wild grasses and boiled water, yet it could easily nourish thousands of beings in all the forests of the many worlds.

In this particular forest were three very disagreeable woodchucks. They were named Bored Woodchuck, Mean Woodchuck and Tiny. Bored, Mean and Tiny had all heard about the miraculous bowl of soup. Bored Woodchuck said, "No way! Soup does not talk. For sure, it is a big joke to get us to buy more soup." Mean Woodchuck said, "I hate anybody that believes in soup. If I ever see that soup I'll spit, kick over the bowl and laugh!" Tiny said, "What if it is too hot and I burn my nose? Then what will become of me?" They continued talking like this as they walked through the forest. Soon they entered a peaceful clearing dappled in sunlight, and there, with a bit of steam curling from its surface, was the bowl of soup. They all approached cautiously.

When Bored Woodchuck looked into the soup he saw his bored reflection along with all the suffering he had caused himself and others. He immediately gained Joyful Mind and saw a way to serve all beings and enjoy life in doing so. From then on he was called Joyful Woodchuck.

When Mean Woodchuck looked into the bowl of soup he saw his mean reflection along with all the hatred he had brought to himself and others. He immediately gained Kind Mind and became like a concerned parent to all beings. From then on he was called Kind Woodchuck.

Tiny got close to the bowl and sniffed its warming aroma. Without worry he took a sip and was instantly transformed into a golden woodchuck. He said "You should allow the four seasons to advance in one viewing, and see an ounce and a pound with an equal eye." It was obvious that he had attained Great Mind. From then on he was called Great.

They all drank from the bowl, which somehow never became empty, and they shared the nourishment with all beings of the forest.

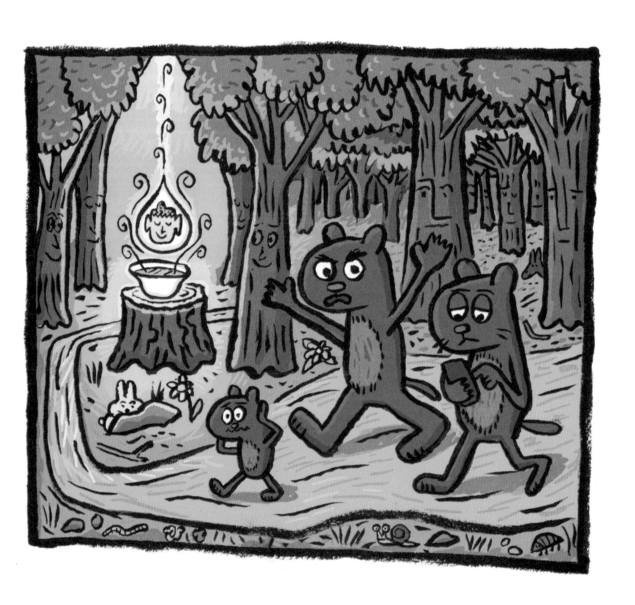

THE DIATOM BUDDHA

Once, a very long time ago in a very distant land, the Buddha was born in the form of hundreds of billions of primordial sea organisms called diatoms. He was microscopic but also huge, living as a massive colony of phytoplankton. While floating peacefully through many lifetimes, the Buddha Diatoms existed in a sea of simple awareness and joy in being diatoms. Of course, one day the life of the Buddha Diatoms came to an end, and they became sediment buried on the ancient sea floor.

Over millions of years they were buried deeper and deeper. This was a long period of profound meditation and quiet. As even more millions of years went by they were compressed by enormous heat and pressure. Eventually they had become a thick brown flammable crude oil. It was a dark existence, but as all different kinds of existences come to an end, the Buddha Crude Oil was pumped up by men who had drilled a deep well. It splashed momentarily into the sunlight and then was put into a secure tank to be transported to a refinery. At the refinery the Buddha Crude was progressively heated and separated by distillation. After traveling through a complex system of processes it emerged at the end of a pipe as lubricating oil, and was placed in a can. The can was placed in a box in a warehouse, and eventually shipped to a distributor. The can that the Buddha Oil happened to be in was sold to a bicycle shop.

One day a young woman named Kimberly brought her bright peach pink bike with a wicker basket to the bicycle shop. The chain was squeaking and she thought it might have come out of alignment. The repair man looked carefully and said "It looks OK. Let's try a little oil." Unbeknownst to him, the oil that he dripped onto the chain was the Buddha. Immediately the chain stopped squeaking, and Kimberly's bicycle rolled smoothly down the street.

Figure 1. Diatoms

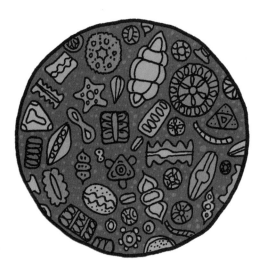

Figure 2. Time and compression

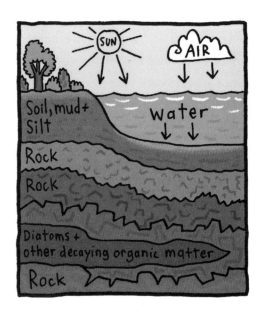

Figure 3. Pumping and refining

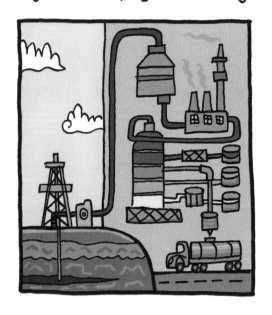

Figure 4. Use

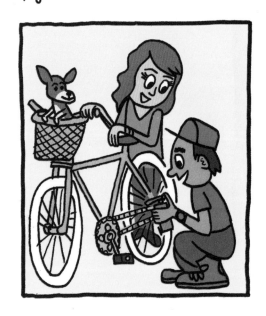

THE BEEF BUDDHA

Once, a very long time ago in a very distant land, the Buddha was born in the form of a cow. He lived his life as a cow, did the things that all cows do, and when the time came, he was slaughtered and his meat, bones, hide and all parts were put to good use. After that he was reborn again as a cow and the cycle continued lifetime after lifetime. The Beef Buddha sometimes lived in the best of circumstances, well tended in beautiful green pastures; in other times he lived in the worst of circumstances, behind steel bars in a factory farm, ankle-deep in manure.

In one particular rebirth he was born into a spacious horse farm of rolling hills covered with soft grass and clover. He was a glorious Black Angus, pampered and prized by the owners. On this farm there was a young woman named Cleo who worked as a barn hand. She was sturdy and beautiful, strong enough to toss heavy hay bales onto a truck, but also loving and empathetic to the plight of all the animals.

One spring day, as she was inspecting the cows in the pasture, her eyes met the eyes of the Beef Buddha who stood serene and glowing in the sunlight. She walked up and stroked the cow's shining black fur. "You are such a beauty," she thought to herself, "too bad you are going to be slaughtered next week." The Beef Buddha heard her thoughts and said out loud "Thank you for noticing me, and I'm not worried about being slaughtered." The young woman was shocked! She jumped back. "You can talk?" The Beef Buddha then told her his story of lifetimes as a cow, the serenity, sorrows, cruelty and kindness he had been witness to.

Tears streamed down Cleo's cheeks. She explained to him how she was a devout vegetarian and an animal lover. Then she burst out, "We've got to do something! You are the Buddha! You can't be sent off to be made into steaks! If you would talk to the world they would stop eating meat. You've got to tell them!"

The Beef Buddha calmly replied, "It wouldn't be appropriate at this time. They would only be suspicious and angry." Cleo was forlorn. "The world stinks," she lamented. "No one is going to believe I met the Beef Buddha, and the meat eating will go on and on and on forever."

"No it won't," the Beef Buddha explained, "I happen to know it will end in 525 years." "525 years! No way!" replied Cleo. "What am I supposed to do?" The Beef Buddha looked lovingly at the beautiful young woman and said, "You will work hard to stop the suffering of all beings. You will live your life as you want everyone to live, with compassion, wisdom and joy. You will fight against the injustices that you feel with your heart. You will laugh and you will teach by the example of your life, and so become an evolved person of the future right now. It sounds difficult, but actually you are already doing it."

Cleo thought for a little while. "So just do what I am doing?" "Just be yourself. Don't worry. That is my teaching to you." "What should I do now?" she asked. "Fetch me another bucket of fresh hay. I'm hungry." So she did.

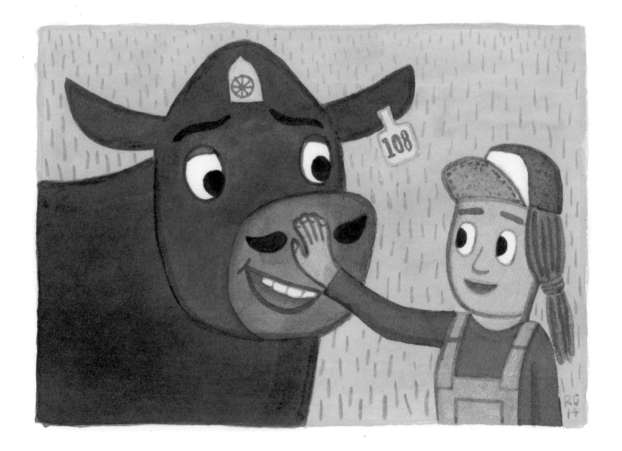

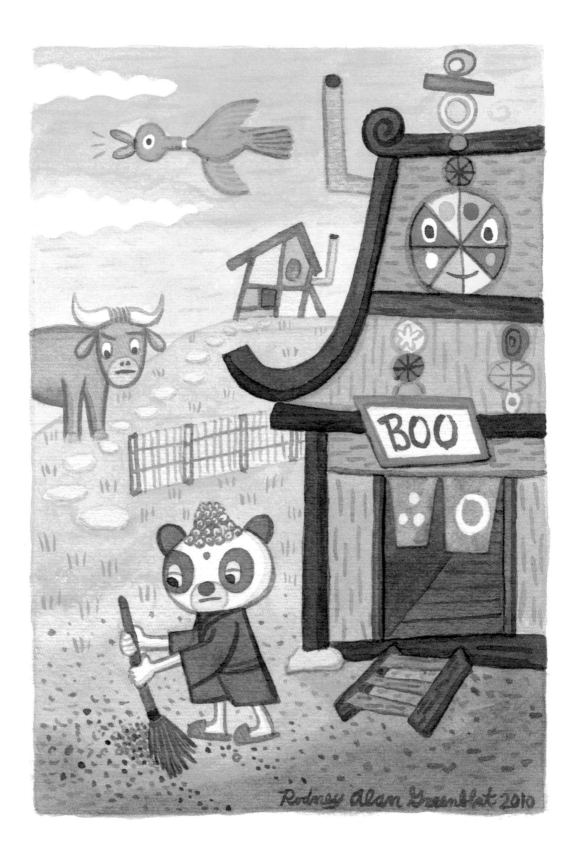

THE BOO TEMPLE

Once, a very long time ago in a very distant land, the Buddha was born in the form of a panda monk called Pandatsu.

Pandatsu had been raised in a big busy temple in the city. There was always noise of other monks running around, bells ringing, guests chatting and the city traffic. There were so many things to do, and it always seemed like everyone was too busy.

When Pandatsu was 47 years old he was given permission by the head priest to start a new temple. Immediately Pandatsu said, "I'll start my new temple on a distant mountain where there is nothing to do. I'll meditate, read the sutras and I'll find quiet, solitude and endless hours of peace." Hearing this the head priest suggested Pandatsu go to the Boo Temple, an abandoned old ruin far from any city. So off he went to find quiet, solitude and endless hours of peace.

Upon arrival he took a deep breath of the fresh mountain air. He heard only birds chirping and the sound of the breeze. The Boo Temple was in bad condition, with holes in the roof and sagging floors. "It's a lot of work," said Pandatsu to himself, "but when it is done I'll find quiet, solitude and endless hours of peace."

Working to restore the temple was hard, and he also had to repair and plant the vegetable gardens. He was endlessly busy. There was a large green goose from a neighboring farm who flew over the Boo Temple and made honking noises all day long. At night a large ox from the same farm would wander onto the temple grounds, trampling the walkways and eating anything in the garden. Bugs, bats and mice were constant visitors.

One day the head priest came to visit. Pandatsu explained all the problems and then asked to return to the city temple. The head priest said, "You may return, but please bring the broken temple, vegetable gardens, ox and goose with you." "Why would I do that?" asked Pandatsu. The head priest then shouted "BOO!" At this Pandatsu realized that quiet, solitude and endless hours of peace can be found at any place and at any time. From that moment on he lived in harmony with all beings.

SIX HEADED JEWEL HOLDER

Once, a very long time ago in a very distant land, the Buddha was born in the form of a spiritual being holding a brilliant jewel. This being had six heads, arranged as one true head surrounded by five invisible heads. So this being was called Six Headed Jewel Holder.

Of the invisible heads, the first was called "Desire of the Senses." This head was always craving delights of sound, sight, smell, taste and touch, and could never get enough.

The second invisible head was called "Ill Will." This head was mean, jealous and resentful, and always in a bad mood.

The third was called "Sloth and Torpor." This head was tired, dull and sluggish, always wanting to lay around doing nothing.

The forth was called "Restless." This head was constantly worried, fearful and uneasy, and could never be at peace.

The fifth head was called "Doubt." This head did not trust anyone or anything, and was always pessimistic and negative.

The sixth head was called "True Head." This was the true head on the shoulders of Six Headed Jewel Holder. Although the five invisible heads were always trying to block and complicate all the hopes, dreams and aspirations of the True Head, the True head was able to live happily, and improve the world. How? Whenever one of the five heads started to cause trouble, the True Head would recognize the existence of that particular head, and accept its point of view. Then the True Head would investigate the motive or intention of the invisible head. Finally the True Head would realize that not only were the other heads invisible, but that they were also momentary and impermanent, and after a time they simply drifted away.

Although it was an everyday, continuing process for the True Head to live openly with the five invisible heads, this process allowed the True Head to be the holder of the brilliant jewel. The brilliant jewel was none other than beautiful daily life in the world as it is right now.

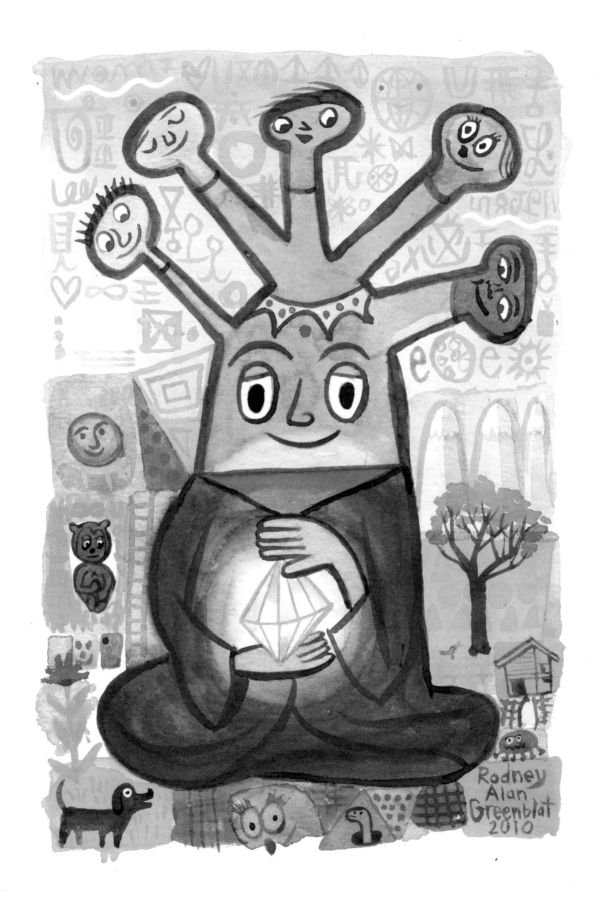

Koans are traditional Zen teaching stories, usually of Chinese origin. The old stories are often the sayings of Zen Masters, interactions with their students, or retold sections of ancient Buddhist lore. Koans are meant to open the Zen eye of the student by forcing them to encounter contradictions and break apart conventional ways of thinking. Koans are still studied by contemporary Zen students who must present their own truth to the master. In this way it can be demonstrated that the student's Zen eye is open and he or she has broken through duality. It is not easy. Look! Look!

Case 4 of the Mumonkan — The Barbarian Has No Beard

Wakuan Shitai 1108-1179?

Bodhidharma (The barbarian?) 470-543?

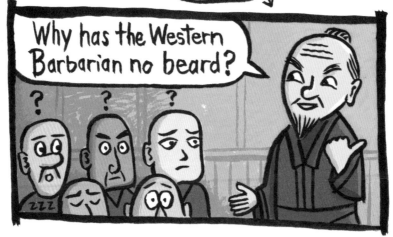

Why has the Western Barbarian no beard?

Mumon's Commentary:
1183-1260

If you practice Zen you must actually practice it. If you become enlightened it must be the real experience of enlightenment. You see this barbarian ONCE face-to-face; then for the first time you will acknowledge him. But if you SAY that you see him face-to-face, in that instant there is division into TWO.

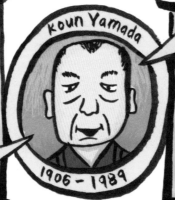

Koun Yamada
1906 - 1989

Everything has two aspects: PHENOMENAL and ESSENTIAL The phenomenal Bodhidharma has a beard, but the essential Bodhidharma has no beard. To REALIZE THIS, you <u>must</u> grasp by experience the essential nature of Bodhidharma.
note: essential nature cannot be destroyed even by karmic fire.

"The barbarian has no beard" —these words themselves are no other than The BEARD. You are self-sufficient and complete as you are so long as you have no BEARD. *But* if upon hearing Wakuan's words, you use your brains and doubt even a bit, a BEARD will sprout and your essential clarity will be obscured by it.

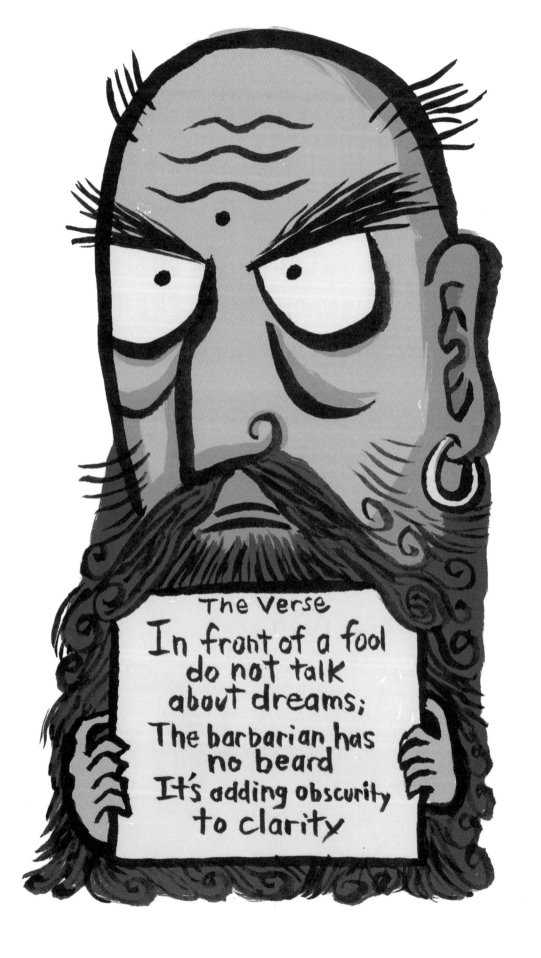

Blue Cliff Record Case 55

TAO Wu's Condolence Call

Point

Secure and intimate with the whole of reality, one obtains realization right <u>THERE.</u> In contact with the *flow* one assumes responsibility **directly.**

As for cutting off confusion in the light of a stone struck spark or flash of lightning, or towering up like a mile high wall where one occupies the tiger's head and takes the tiger's tail — this I leave aside for the moment. Is there a way to **HELP PEOPLE** by letting out a continuous **PATH** or **not?** To test, I cite this: **LOOK!**

Tao Wu and Chien Yuan went

to a house to make a condolence call. Yuan hit the coffin and said, "Alive or dead?" Wu said, "I won't say alive, and I won't say dead." Yuan said, "Why won't you say?" Wu said, "I won't say." Halfway back, as they were returning, Yuan said, "Tell me right away, Teacher; if you don't tell me, I'll hit you." Wu said, "You may hit me, but I won't say." Yuan then hit him.

Later Tao Wu passed on. Yuan went to Shih Shuang and brought up the foregoing story. Shuang said, "I won't say alive, and I won't say dead." Yuan said, "Why won't you say?" Shuang said, "I won't say, I won't say." At these words Yuan had an **INSIGHT**

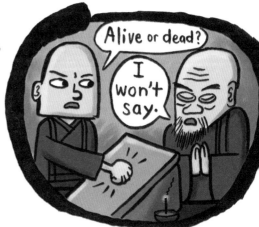

One day Yuan took hoe into the teaching hall and crossed back and forth, from east to west and west to east. Huang said, "What are you doing?" Yuan said, "I'm looking for the relics of our late master." Huang said, "Vast Waves spread far and wide, foaming billows flood the skies—What relics of our late master are you looking for?"

Hsueh Tou added a comment saying:

HEAVENS! HEAVENS!

Yuan said,

This is just where I should APPLY EFFORT.

Fu of Tái Yuan said,

The late master's relics are STILL PRESENT.

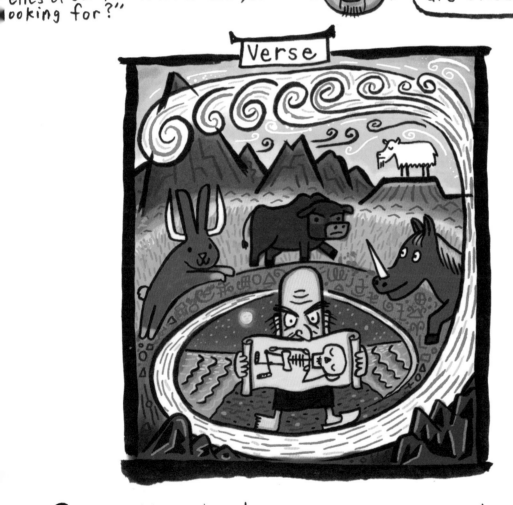

Verse

Rabbits and horses have horns—Oxen and rams have no horns.
Nary a hair, nary a wisp—Like mountains, like peaks.
The golden relics still exist right now.
With white foaming waves flooding the skies, where can they be put?
There is no place to put them—
Even the one who returned to the West with one shoe has lost them.

The Iron Flute case 62
Nanchuan's Little Hut

One day, while Nachuan was living in a little hut in the mountains, a strange monk visited him as he was preparing to go to his work in the fields. Nanchuan welcomed him, saying "Please make yourself at home. Cook anything you like for your lunch, then bring some of the leftover food to me along the road leading nowhere but to my work place." Nanchuan worked hard until evening and came home very hungry. The stranger had cooked and enjoyed a good meal by himself, then thrown away all the provisions and broken all the utensils. Nanchuan found the monk sleeping peacefully in the empty hut, but when he stretched his own tired body beside the stranger's, the latter got up and went away. Years later, Nachuan told the anecdote to his disciples with the comment, "He was such a good monk, I miss him even now."

Senzaki's Comment

Zen takes food from a hungry man and the sword from a soldier. Anything to which one attaches himself most is the real cause of suffering. The strange monk wished to give Nanchuan nothing but true emancipation.

Instructions from Musho

Print a copy of this page from dharmadelight.com/hut. Cut it out carefully along the black lines. Fold like this: Glue or tape these tabs: Finished hut.

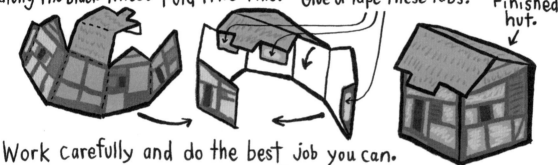

Work carefully and do the best job you can. Praise yourself and show your friends and family what a good job you have done.

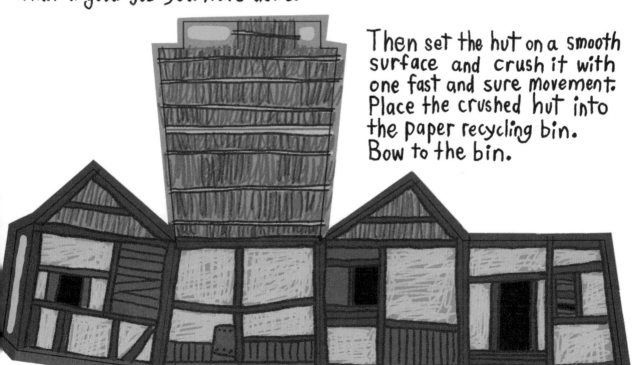

Then set the hut on a smooth surface and crush it with one fast and sure movement. Place the crushed hut into the paper recycling bin. Bow to the bin.

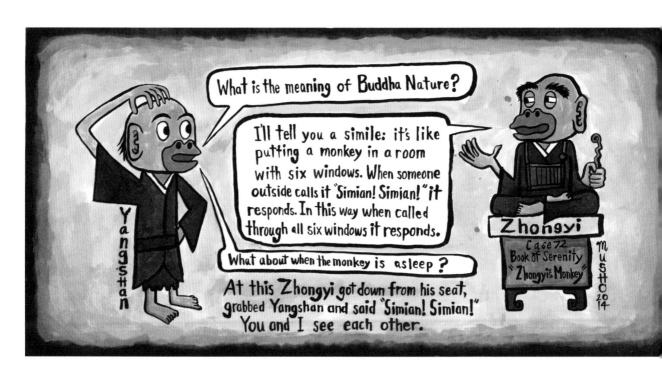

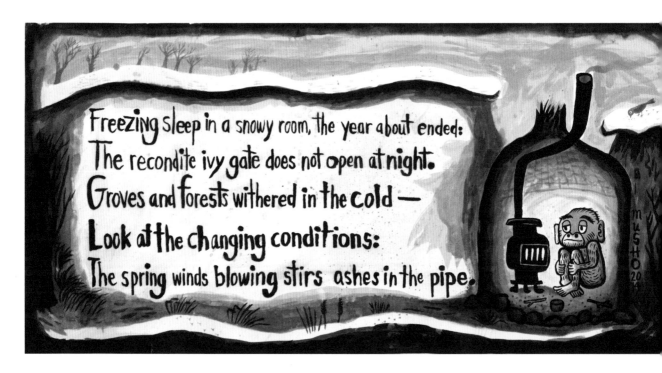

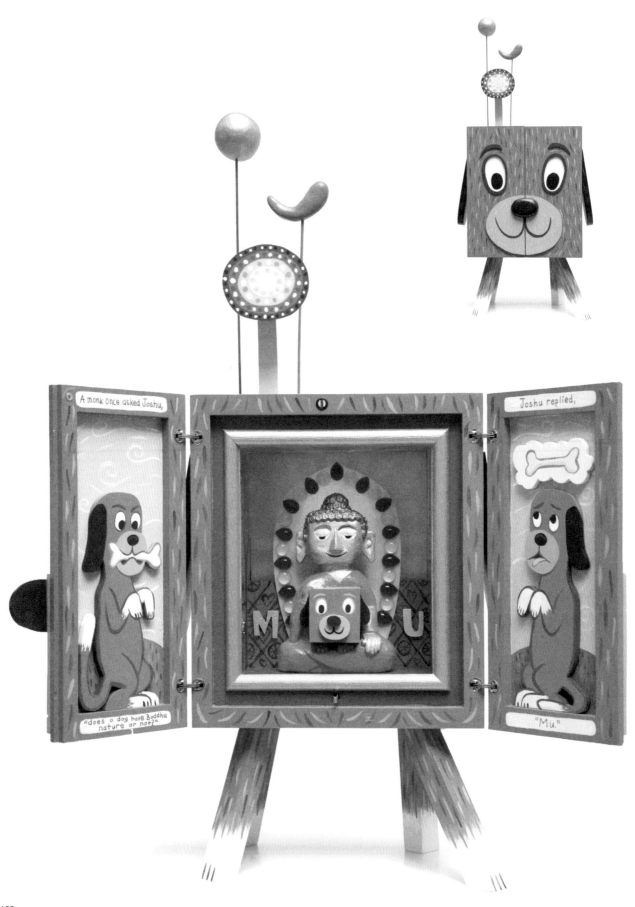

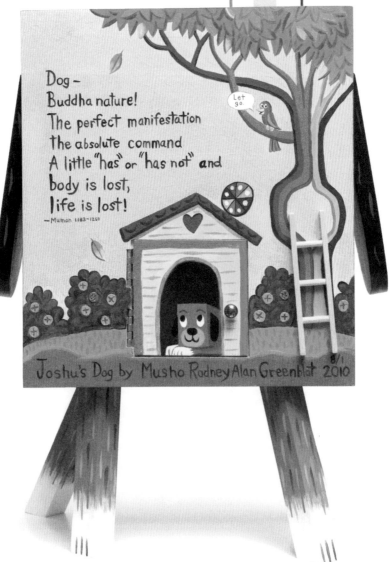

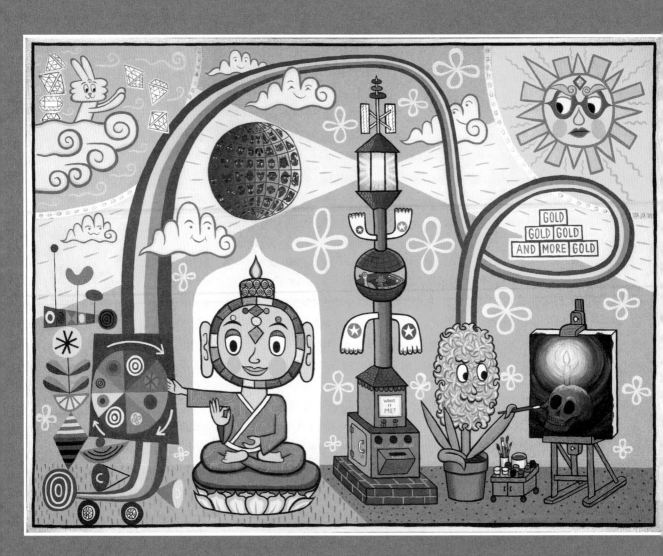

Case 39 of the Blue Cliff Record
Yun Men's Flowering Hedge

pointer

One who can take action on the road is like a tiger in the mountains; one immersed in worldly understanding is like a monkey in a cage. If you want to know the meaning of Buddha nature, you should observe times and seasons, causes and conditions. If you want to smelt pure gold which has been refined a hundred times, you need the forge and bellows of a master. Now tell me, when one's great function appears, what can be used to test him?

case

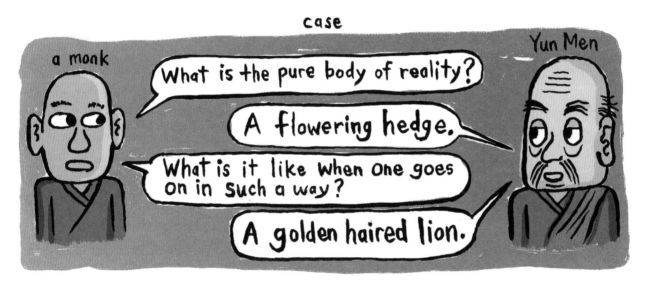

a monk

What is the pure body of reality?

A flowering hedge.

What is it like when one goes on in such a way?

A golden haired lion.

Yun Men

verse

A flowering hedge:
Don't be fatheaded!
The marks are on the balance arm, not on the scale pan.
"So just be like this"—
How pointless!
A golden-haired lion— everybody look!

The Wonder Verified and Fulfilled
from Cultivating the Empty Field

Master Hongzhi said:

The Dharma in the ten directions arises from the single mind. When the single mind is still, all appearances are entirely exhausted. Which one is over there? Which one is myself? Only when you do not differentiate forms, suddenly not a single dust is established, not a single recollection is produced. Discern that even before the pregnant womb and after your skin bag, each moment is astonishing radiance, full and round without direction or corners, discarding trifles. Where truly nothing can be obscured is called self knowledge. Only thus knowing the self is called original realization, not even a hair received undeservingly. Magnificent, subtly maintaining uniqueness, genuine hearing is without sound. So it is said that perceiving without eye or ear is where the wonder is verified and fulfilled. Light streams forth from there and many thousands of images appear. Every being is actually it, altogether in the realm where patch-robe monks function on their own. It is essential only not to borrow from other people's homes. To cultivate our house you must clearly and intimately experience it for yourself.

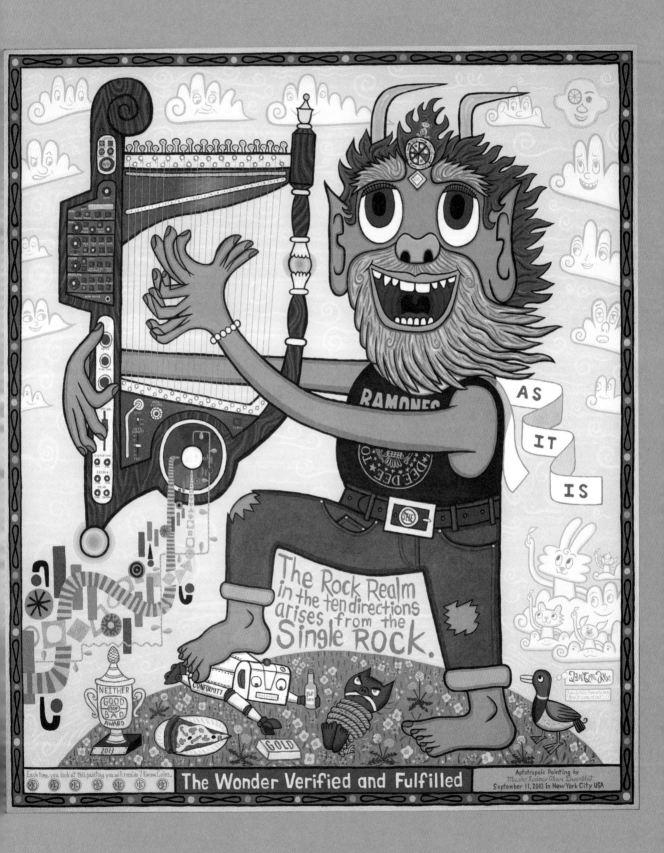

AS IT IS

The Rock Realm in the ten directions arises from the Single ROCK.

NEITHER GOOD nor BAD AWARD
2013

CONFORMITY

GOLD

Each time you look at this painting you will receive 7 Karma Coins.

The Wonder Verified and Fulfilled

Apotropaic Painting by
Mucho Rodney Alan Greenblat
September 11, 2013 in New York City USA

105

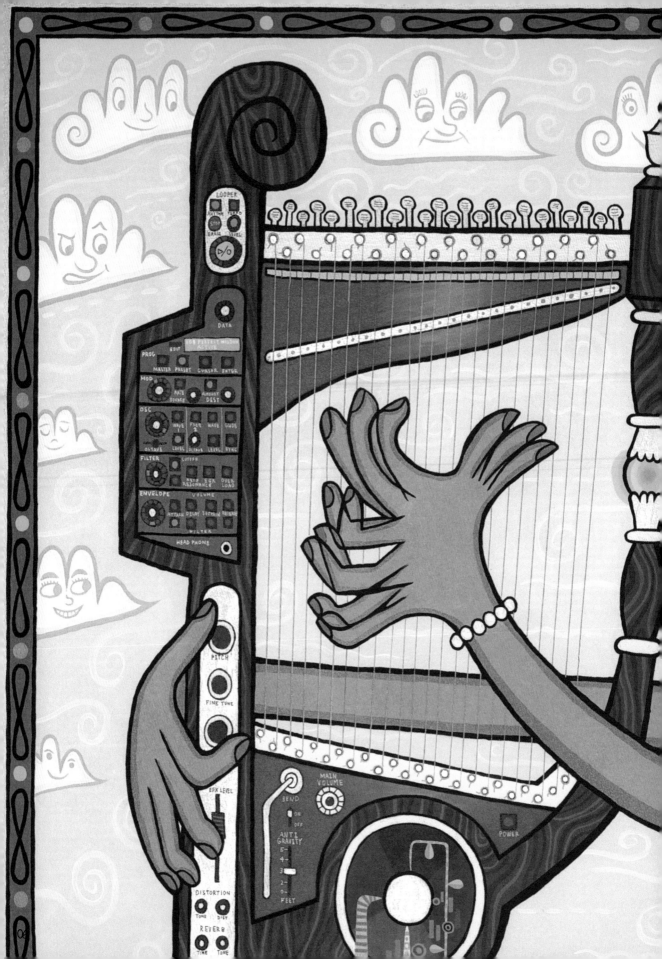

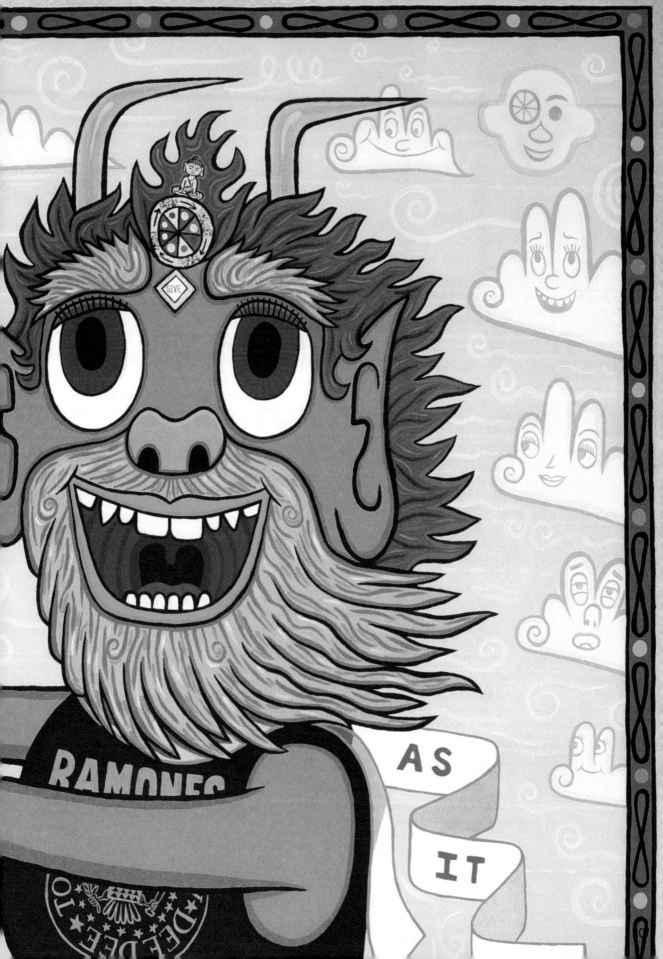

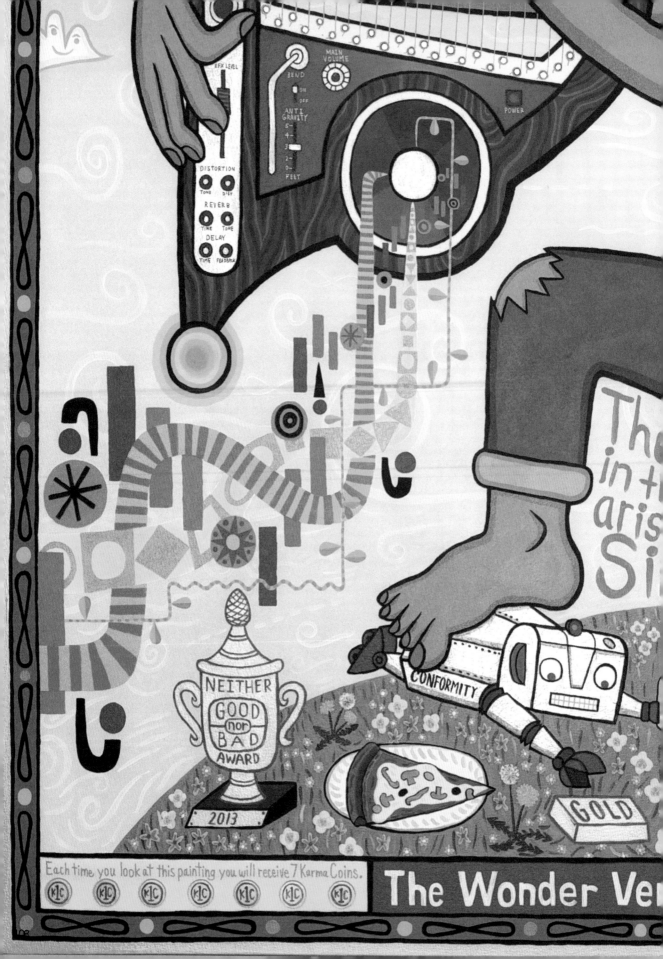

RAMONES

DEE DEE

SELF

AS
IT
IS

...ck Realm
...directions
...rom the
ROCK.

Self Critic

Translation from wild duck:
"Now it is one of us!"

d and Fulfilled

Aptotropaic Painting by
Musho Rodney Alan Greenblat
September 11, 2013 in New York City USA

109

Rodney 2014

Case 46 from the Mumonkan
Step Forward From the Top of a Pole

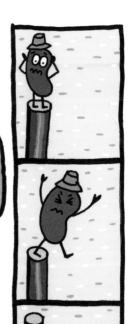

Master Sekiso

From the top of a pole one hundred feet high, how do you step forward?

Ancient Master Chosa

One sitting on the top of a pole one hundred feet high, even if he has attained "it," has not been truly enlightened. He must step forward from the top of a pole one hundred feet high and manifest his whole **body in the ten directions.**

Master Mumon

If you can step forward and turn back, is there anything you dislike as unworthy? But even so, tell me, from the top of a pole one hundred feet high, how do you step forward?

Verse:

The eye in the forehead has gone blind,
And he has been misled by the stuck pointer on the scale,
He has thrown away his body and laid down his life—
A blind man is leading other blind men.

Why is he blind?

Zen Training

ZenTraining
Community – Posture – Breath – Mind

1. Find a meditation COMMUNITY near you and try it out.

The most important step you can take towards a meaningful meditation practice is to search on the internet to find a nearby meditation center. Every center is different, with different rituals, meditation styles and schedules. Go there and try it a few times, enough to meet some of the members and the teachers. You will know if it is right for you.

What if after a few visits I don't like the teachers or other members?

That's ok. Keep searching and trying different places. Find the one that makes sense to you. Don't give up.

A Buddhist community is called a SANGHA. While it is possible to have a strong meditation habit at home, the benefits of belonging to a Sangha are profound. It could be said that Sangha is the ultimate objective of Buddhism: to form caring communities that extend out from a circle of friends to neighborhoods, towns, cities, states, nations and the Great Sangha of the whole world.

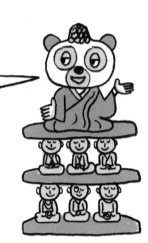

ZenTraining
Community – Posture – Breath– Mind

2. Develop a seated meditation POSTURE that is comfortable for you.

Here is a brief description of the basics of "Zazen" seated meditation in the Japanese Zen style.

You must sit upright, in a relaxed and attentive way. Your posture is the reflection and embodiment of all the Buddhas that ever sat in meditation.

Please buy this kind of mat and cushion set for home use.

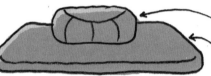

"Zafu" bean bag style.
"Zabuton" thick cotton batting

Full Lotus: Feet are both placed on thighs.	**Half Lotus:** One foot on thigh, the other on the floor.	**Side View:**
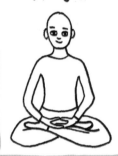	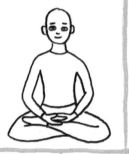	Eyes open looking down — Facing the wall — 45° 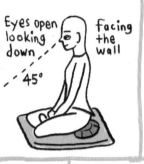

Burmese: Legs folded with both feet on the floor.	**Seiza:** Knees on floor, sitting on the zafu.	**Seiza Bench:** Sitting on bench, legs folded underneath.	**Chair:** Back is straight.
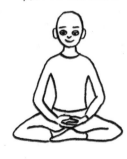	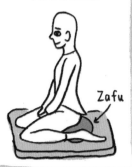 Zafu	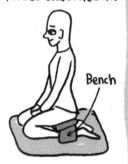 Bench	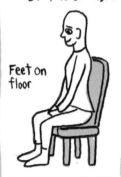 Feet on floor

Zen Training
Community – Posture – Breath – Mind

3. Attention to the BREATH is the most basic activity to concentrate on.

Your life is sustained by the simple rhythm of your breath. But what is it? Flowing in and out like the ocean waves on the shore, deep or shallow, follow the breath and you follow the energy of the whole world.

Basic breath meditation

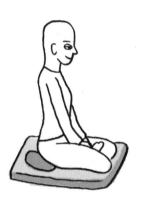

Counting Breath:
Count each natural cycle of breath silently in your mind.

Breath in-and-out 1
Breath in-and-out 2
Breath in-and-out 3...
and so on up to 10 and then start over.

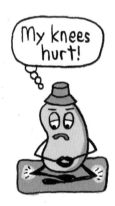

My knees hurt!

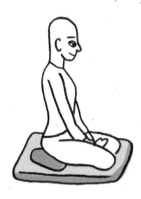

Watching Breath:
Pay attention to each natural in-and-out cycle of breath.

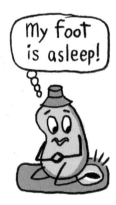

My foot is asleep!

A period of meditation should be 15 minutes at least. Meditation centers usually have 25-30 minute periods, others 45 to one hour.

Zen Training
Community – Posture – Breath – Mind

4. Sensing the functioning of MIND is the awakening of a Buddha.

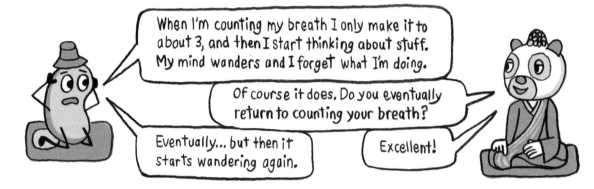

When I'm counting my breath I only make it to about 3, and then I start thinking about stuff. My mind wanders and I forget what I'm doing.

Of course it does. Do you eventually return to counting your breath?

Eventually... but then it starts wandering again.

Excellent!

Thoughts are just thoughts.

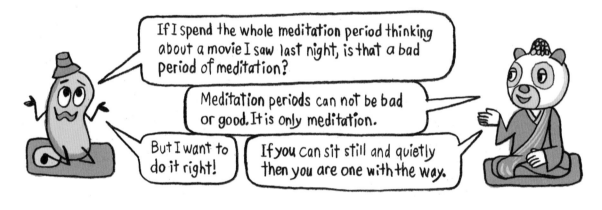

If I spend the whole meditation period thinking about a movie I saw last night, is that a bad period of meditation?

Meditation periods can not be bad or good. It is only meditation.

But I want to do it right!

If you can sit still and quietly then you are one with the way.

The benefits are for all beings.

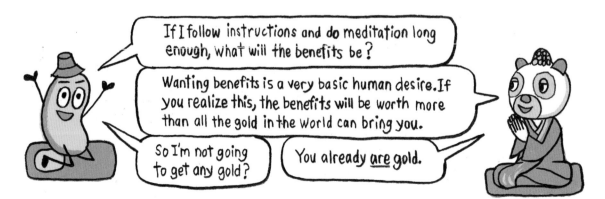

If I follow instructions and do meditation long enough, what will the benefits be?

Wanting benefits is a very basic human desire. If you realize this, the benefits will be worth more than all the gold in the world can bring you.

So I'm not going to get any gold?

You already are gold.

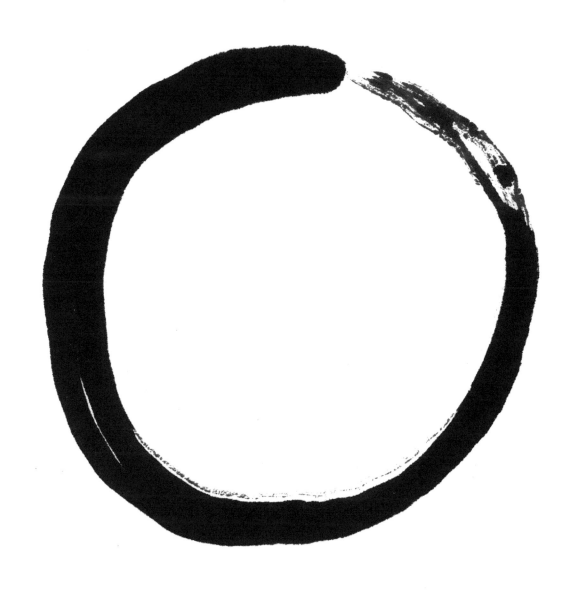

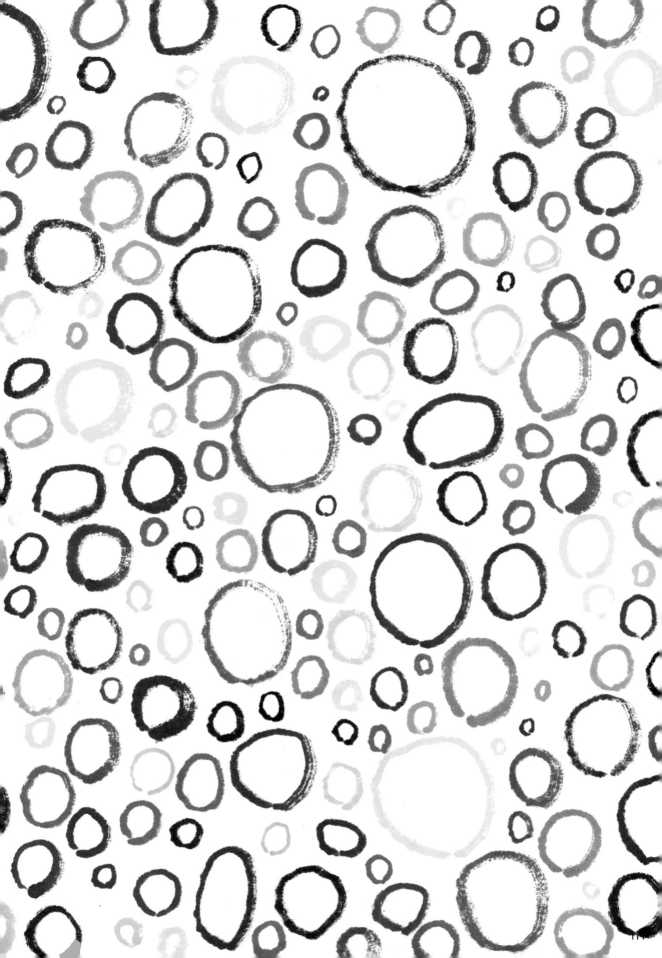

Notes

1: *A Primitive Buddha*. Watercolor on paper, 9 x 9 in., 2007.

2: *Buddha Talking Ok*. Watercolor on paper, 9 x 9 in., 2007.

4: *Loki*. Water Color on paper, detail from book Thunder Bunny Helps Shypupu (Japan: Interlink, 2009).

7: Confidence. Ink on handmade paper, 11 1/2 x 4 in., 2011.

9: No Expectations. Black and gold ink on handmade paper, 4 x 6 in., 2013.

10: *Tea House Buddha*. Ink on paper with digital coloring ,7 x 8 in., 2008.

12: "The Buddha turns the Dharma Wheel and reality is shown in all it's many forms" from Village Zendo chant and dedication book.

13: "The Dharmas are boundless, I vow to master them" Number 3 of the 4 Bodhisattva Vows recited at the Village Zendo.

15: *Dharma Delight Mandala*. Digital painting, 12 x 15 in., 2014.

16: *Morning Star Sight*. Acrylic on canvas, 11 x 9 in., 2009.

17: "Buddhas" title page art. Marker on paper with digital coloring, 6 x 7 in., 2014.

19: *Rohatsu in the City*. Watercolor on paper, 7 x 10 in., 2009.

20: *Study Your Self*. Watercolor on paper, 8 x 8 in., 2011.

21: Dogen Zenji, *Moon in a Dew Drop: Writings of Zen Master Dogen*, ed. Kaz Tanahashi (New York: North Point Press 1985).

22: *Vegan Sandwich*. Watercolor on paper, 8 x 8 in., 2011.

23: Shakyamini quote from "Lankavatara Sutra" chapter 16: Do Not Eat Meat, Translated into English by Silfong Tsun, revised 2008.

25: *Lamp to Your Self*. Watercolor on paper, 8 x 8 in., 2011.

32: *Mirror Nature*. Watercolor on paper, 9 x 9 in., 2009.

33: *Buddha Vacuuming*. Watercolor on paper, 9 x 9 in., 2010.

34: *Trumpet of Buddha*. Watercolor on paper, 18 x 24 in., 2007.

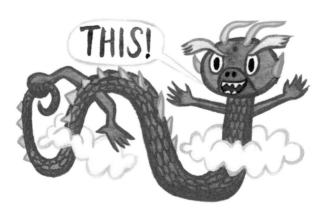

35: *Sitting in the Mountain*. Watercolor on paper, 12 x 16 in., 2007.

36: *Buddha Time Protector*. Digital painting, 5 x 6 in., 2013.

37: *Buddha Space Protector*. Digital painting, 5 x 6 in., 2013.

38 – 44: *Wow Temple*. Acrylic on canvas, 48 x 42 in., 2010.

46: *Manjushri Sets Forth*. Ink on handmade paper, 4 x 4 in. 2011.

47: "Bodhisattvas" title page art. Marker on paper with digital coloring, 6 x 7 in., 2014.

49: *Manjushri Rides*. Watercolor on paper, 11 x 15 in., 2011.

51: *Samantabhadra Rides*. Watercolor and ink on paper, 18 x 14 in., 2007.

53: *Kanzeon with 22 Arms* Digital painting, 8 x 10 in., 2014.

54: *Jizo with Staff*. Watercolor on paper, 9 x 9 in., 2008.

57: *Vimalakirti with Visitors*. Digital painting, 5 x 9 in., 2014.

58 – 59: *Who is Maitreya?* Digital painting, 15 x 10 in., 2014.

62: *Dragon Gate Open 24/7*. Ink on handmade paper, 4 x 4 in., 2011.

63: "Gate Guardians" title page art. Marker on paper with digital coloring, 6 x 7 in., 2014.

64: *Gate Protector Red*. Acrylic on wood, 9 x 15 in., 2014.

65: *Gate Protector Green*. Acrylic on wood, 9 x 15 in., 2014.

66: *Garuda Princess Invincible Virtue Leader*. Acrylic on canvas, 30 x 24 in., 2012.

67: *Yaksha Prince Great Mystery Holder*. Acrylic on canvas, 30 x 24 in., 2012.

68: *Faith, Doubt and Tortoise*. Acrylic on canvas, 32 x 45 in., 2012.

71: *Fudo Freedman the Temple Gate Guardian*. Acrylic on canvas, 36 x 30 in., 2012.

73: *Gone Beyond Dog King Zenji*. Acrylic on canvas, 42 x 48 in., 2012.

74: *Jataka Tales Scene*. Ink on paper with digital coloring, 8 x 10 in., 2010.

75: "Jataka Tales" title page art. Marker on paper with digital coloring, 4$^{1}/_{2}$ x 7 in., 2014.

77: *The Patient Buffalo*. Watercolor on paper, 7 x 10 in., 2014.

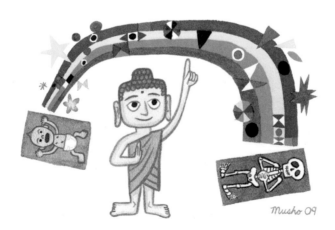

Notes continued

79: *The Talkative Tortoise*. Watercolor on paper , 7 x 10 in., 2014.

81: *Three Woodchucks*. Ink on paper with digital coloring 6¹/₂ x 5 in., 2011. This story is inspired by Dogen Zenji's essay "Instructions for the Tenzo" including a direct quote: "You should allow the four seasons to advance in one viewing, and see an ounce and a pound with an equal eye." From *Moon in a Dew Drop*, edited by Kaz Tanahashi (New York: North Point Press, 1985).

83: *From Diatom to Oil*. Ink on paper with digital coloring, 7 x 10 in., 2014.

85: *Cleo with the Beef Buddha*. Watercolor on paper, 6 x 4 in., 2014.

86: *Boo Temple*. Watercolor on paper, 5¹/₂ x 8 in., 2010.

89: *Six Headed Jewel Holder*. Watercolor on paper, 7 x 10 in., 2010. This story is inspired by the traditional "Five Hindrances" of Buddhist practice.

91: "Koans" title page art. Ink on paper with digital coloring , 5 x 5 in., 2014.

92-93: "Case 4 of the Mumonkan" quoted from *The Gateless Gate: the Classic Book of Zen Poems* by Koun Yamada (Somerville: Wisdom Publications, 2004).

94-95: "Case 55 of the Blue Cliff Record" quoted from *The Blue Cliff Record*, translated by J.C. Clearly and Thomas Cleary (Boston: Shambhala Publications, 2005).

96-97: "Case 62 of The Iron Flute" quoted from *The Iron Flute: 100 Zen Koans* by Nyogen Senzaki (Boston:Tuttle Publications, 2000).

98-99: "Case 72 of The Book of Serenity" quoted from *Book of Serenity: One Hundred Zen Dialogues*, translated by Thomas Cleary, (Boston: Shambhala Publications, 2005). Artworks, each, ink on paper, 29 x 60 in., 2014.

100-101: *Joshu's Dog*. Constructed sculpture of wood, ceramic acrylic paint, hardware and battery operated light, 24 x 12 x 6 in., 2010. Contains quotes from "Case 1 of the Mumonkan" from *The Gateless Barrier* by Zenkei Shibayama (Boston: Shambhala Publications, 2000).

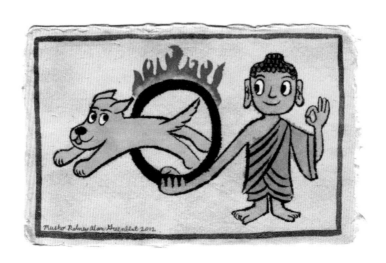

102: *The Inexhaustible Lamp*. Acrylic on canvas, 40 x 50 in., 2012.

103: "Case 39 of the Blue Cliff Record" quoted from *The Blue Cliff Record*, translated by J.C. Clearly and Thomas Cleary (Boston: Shambhala Publications, 2005).

104: Zen Master Hongzhi quoted from *Cultivating the Empty Field* by Taigen Dan Leighton (Boston: Tuttle Publishing, 2000).

105-109: *The Wonder Verified and Fulfilled*. Acrylic on canvas, 70 x 60 in., 2013.

110: *Stepping Forward*. Acrylic on canvas, 9 x 12 in., 2014.

111: "Case 46 of the Mumonkan" quoted from *The Gateless Barrier* by Zenkei Shibayama (Boston: Shambhala Publications, 2000).

115: Zafu and Zabuton sets are available from Dharmacrafts.com as well as other meditation supply companies. The drawings of meditation postures are copied from *Zen Training, Methods and Philosophy* by Katsuki Sekida (Trumbull: Weatherhill Publishing 1975).

118: *One Absolute Circle*. Ink on paper, 8 x 10 in., 2014.

119: *Many Relative Circles*. Ink on paper, 8 x 10 in., 2014.

120: *Dharmo Says This*. Watercolor on paper, 4 x 6 in., 2012.

121: *Buddha Points*. Watercolor on paper, 4 x 6 in., 2009.

122: *Though The Hoop*. Watercolor on handmade paper, 4 x 6 in., 2012.

123: *Buddha Protected By Lions*. Watercolor on handmade paper, 4 x 6 in., 2012.

125: *All Universe Time Space Wisdom Stupidity Radiate From This Point*. Acrylic on wood, 18 x 18 in., 2008.

126: *Self Portrait with Hindrances*. Watercolor on paper, 10½ x 7 in., 2010.

127: *Winter Way*. Digital painting, 4 x 6 in, 2012.

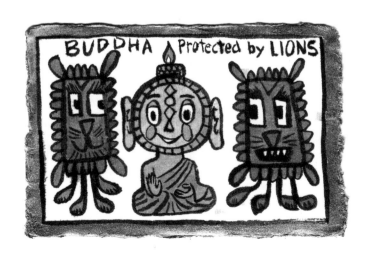

All Universe Time Space Wisdom Stupidity Radiate From This Point

artwork by

Rodney Alan Greenblat

February 14th 2008

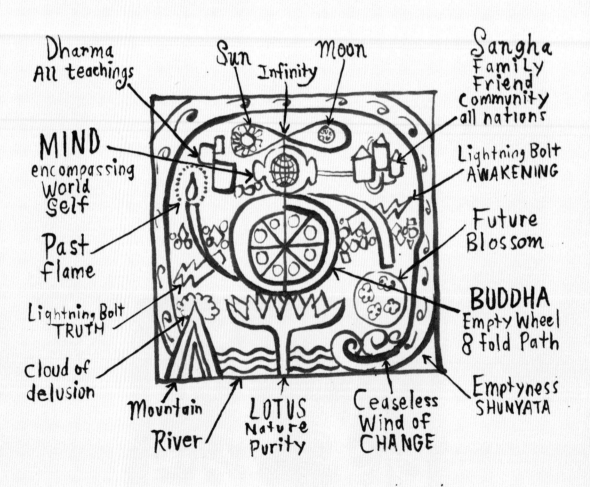

Dharma All teachings

Sun

Infinity

Moon

Sangha Family Friend Community all nations

MIND encompassing World Self

Past flame

Lightning Bolt AWAKENING

Future Blossom

Lightning Bolt TRUTH

Cloud of delusion

BUDDHA Empty Wheel 8 fold Path

Emptyness SHUNYATA

Mountain

River

LOTUS Nature Purity

Ceaseless Wind of CHANGE

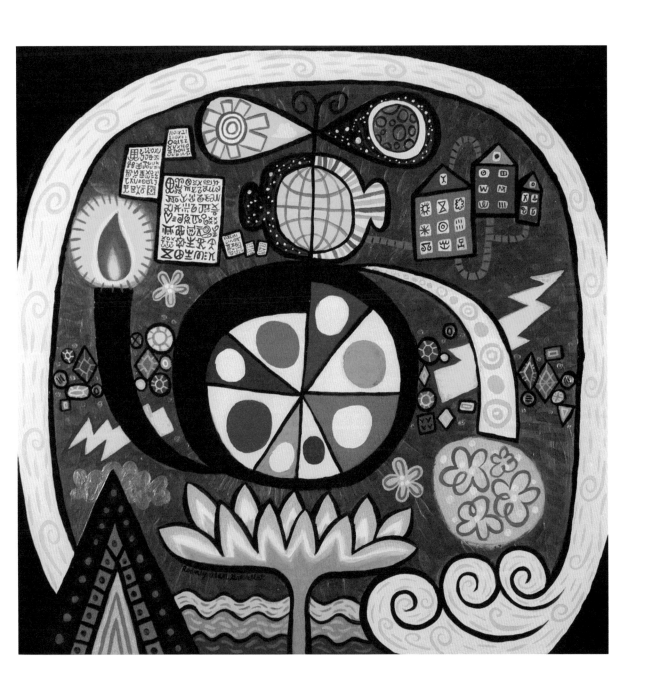

About the Author

Rodney began drawing and painting at the age of three. His big break came in 1970 when, at the age of ten, he was given the opportunity to illustrate the cover of his elementary school parent-teacher association handbook. Years later he moved to New York City, and his lively, colorful sculptures and paintings became an integral part of the ballooning East Village art scene, including several one-person shows at the legendary Gracie Mansion Gallery. In 1985 his large sculpture "Ark of Triumph" was featured in the prestigious Whitney Museum Biennial Exhibition. In the 1990s Rodney's experimentation with the personal computer led him to the production of interactive CD-ROMs and then to the video game industry. He became the artistic force behind the best-selling Sony PlayStation® game "PaRappa The Rapper." This led to a whole line of popular consumer products distributed in Japan, as well as a weekly animated television series, also in Japan. Rodney has been creating characters and illustrations for some of the world's most respected companies and publications, including Family Mart, Sony, Toyota, The New Yorker and The New York Times. Rodney is a senior student at the Village Zendo Zen center in New York City where he has received the Buddhist name "Musho." Rodney continues his colorful and enchanting way of true expression.

See more of Rodney's artwork on his website whimsyload.com

Copyright

Library of Congress Control Number: 2015956527

ISBN 978-0-8048-4526-7

Distributed by

North America, Latin America and Europe
Tuttle Publishing
364 Innovation Drive
North Clarendon, VT 05759-9436 USA
Tel: (802) 773-8930
Fax: (802) 773-6993
info@tuttlepublishing.com;
www.tuttlepublishing.com

Japan
Tuttle Publishing
Yaekari Building 3rd Floor
5-4-12 Osaki, Shinagawa-ku Tokyo 141 0032
Tel: (81)3 5437-0171
Fax (81)3 5437-0755
sales@tuttle.co.jp
www.tuttle.co.jp

Asia Pacific
Berkeley Books Pte. Ltd.
61 Tai Seng Avenue #02-12
Singapore 534167
Tel: (65) 6280-1330
Fax (65) 6280-6290
inquiries@periplus.com.sg
www.periplus.com

First edition
20 19 18 17 16 5 4 3 2 1

Printed in Malaysia 1601TWP

This colorful, fun, and gorgeous meditation on Buddhism is sure to delight anybody who encounters it! Rodney's fantastical style makes this a true work of art, as well as an informative volume for those who are practicing, or even just curious about Zen.

—Abby Denson, comic artist, musician and author of *Cool Japan Guide*

Zen teaching, long known for its spiritual humor, here finds vibrantly new, playfully authentic life. When Original Face meets Original Mind we are in for a treat. *Dharma Delight* is a wonderfully unique and quite genuine Zen book like no other.

—Rafe Martin, Zen teacher and author of The *Banyan Deer* and *Endless Path*

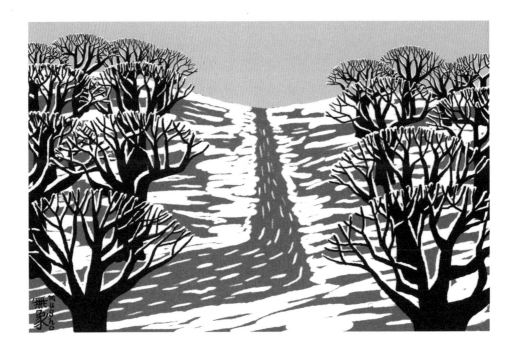

About Tuttle
"Books to Span the East and West"

Our core mission at Tuttle Publishing is to create books which bring people together one page at a time. Tuttle was founded in 1832 in the small New England town of Rutland, Vermont (USA). Our fundamental values remain as strong today as they were then—to publish best-in-class books informing the English-speaking world about the countries and peoples of Asia. The world has become a smaller place today and Asia's economic, cultural and political influence has expanded, yet the need for meaningful dialogue and information about this diverse region has never been greater. Since 1948, Tuttle has been a leader in publishing books on the cultures, arts, cuisines, languages and literatures of Asia. Our authors and photographers have won numerous awards and Tuttle has published thousands of books on subjects ranging from martial arts to paper crafts. We welcome you to explore the wealth of information available on Asia at **www.tuttlepublishing.com**.